IMAGES
of America

WELLFLEET
A CAPE COD VILLAGE

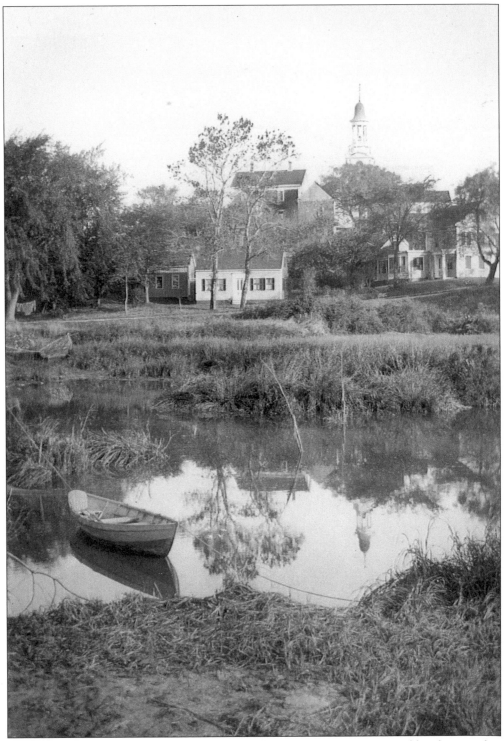

WELLFLEET IN THE LATE 19TH CENTURY. This peaceful scene was captured by photographer Clifton Johnson.

IMAGES
of America

WELLFLEET
A CAPE COD VILLAGE

Daniel Lombardo

ARCADIA

Cover image: YOUNG CAROL MAYO NICKERSON AT THE WHEEL OF THE ARAWAK IN 1896. Behind Carol Mayo Nickerson are her parents, Henry Crosby Nickerson and Dora Mayo Nickerson. (Photograph used with permission of Susan Ryder Hamar, the granddaughter of Carol Mayo Nickerson.)

Acknowledgments

Heartfelt thanks to the Wellfleet Historical Society, especially Betsy Cole, Joan Coughlin, and Helen Purcell—each knowledgeable and delightful. The society's museum and archives were generously opened to me, and the majority of photographs herein (unless otherwise marked) are found there. I spent many pleasant hours with Hope Morrill, the curator of the National Seashore Archives in Eastham. Her expertise and kindness helped make this project a pleasure. Photographs from the National Seashore Archives are labeled (N.S.). Many thanks to my Wellfleet neighbors Sue and Dan Hamar, Julian Anthony, and Dot and John O'Brien. My gratitude to Princess Elettra Marconi, Bill and Phyllis Crockett, Phyllis Scott, William Quinn, Ron Buck, Mary Sicchio of the Nickerson Room at Cape Cod Community College, and William F. Fowler Jr., director of the Massachusetts Historical Society. Thanks to Amy Sutton, publisher at Arcadia, for editorial and microwave advice. Special thanks to Karen Banta. *Wellfleet: A Cape Cod Village* is dedicated to Mary Vasquez Lombardo and Marie DeSpelder Banta.

CONTENTS

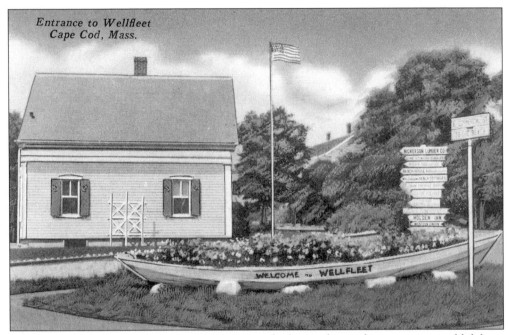

*Entrance to Wellfleet
Cape Cod, Mass.*

A JACOB'S GARDEN. This classic picture postcard of a Jacob's garden is set in an old fishing dory at the entrance to Wellfleet. Gardens such as this were named after a minister who found his garden relocated into his boat after a hurricane.

INTRODUCTION

Shortly after 8:00 each morning at Wellfleet Harbor, I can hear a booming echo from Indian Neck to the woods of Great Island. I imagine that it is the ancient drumming of the souls of the Punanokanit Indians who are buried in both places. One Wellfleet old-timer tells me that it is only the thunder of the sound barrier, broken by an unseen Concorde jet as it makes its way from Boston to Paris. I do not believe him.

Wellfleet is a quintessential Cape Cod village, and it is to Wellfleet that I am continually drawn by the ache of salty dreams. At the top of the village is the old steeple, still tolling the hours according to ships' bells. The white and pale yellow homes and shops along Main Street have changed little over the generations. Now, many of them house the art galleries for which the town is justly famous. Below the village is one of the prettiest harbors on the Cape. At dawn, lobster and oyster boats leave the same port from which earlier fleets of fishing and whaling vessels sailed.

Remains of the old wharves, the ship's carpenter shop, the so-called Customs House, and the lighthouse can still be seen. At the western end of Wellfleet Harbor is Great Island, where Smith's Tavern once stood. There, archaeologists have found broken wineglasses, oyster shells, whale bones, a harpoon shaft, a lady's ivory fan, and part of a man's skull.

Just south of Great Island is the shoal where Billingsgate Island once was. Lighthouse keeper Herman Dill wrote the following in his log:

> December 21, 1874: We have had quite a heavy blow and a very high tide, the highest for a number of years. [The sea] broke through at the north end of the island, filling the middle of the island full, running up to the south corner of the foundation on which stands the lighthouse, carrying away the walk which leads to the wharf. I could stand on the south corner and jump into four feet of water.

> February 7, 1875: it has been very Cold here for the Last Month and the most ice that I ever see. . . . We are almost buried up in it. No salt water to be seen from the Island I have not Seen a Living man for over a month no prospect for the Better. I do get the Blues some times. . . . I Can Not Move in either Direction for the ice is 15 feet high in some places."

November 17, 1875: "i do not know but the Island will All wash away."

March 26, 1876: "the very worst storm for the winter was Last Night."

The entry on March 26 was his last. Herman Dill was found dead, afloat in the lighthouse dory the following day. The remnants of the island's village, tavern, and lighthouse slowly washed into the sea more than 60 years ago.

Of the many shipwrecks in Wellfleet waters, the most famous is the wreck of the *Whydah*, the pirate ship of "Black Sam" Bellamy. It sank in a storm in 1717 and is the first pirate ship ever to have been excavated. Gold and silver, pirates' clothing, cannons, and the ship's bell can be seen in a new museum in Provincetown. Less known is the wreck of the barque *Castagna*, from Genoa, Italy. On February 23, 1914, the *Barnstable Patriot* reported that "Eight men, all badly frost-bitten and nearly unconscious from exposure, were brought ashore by the life savers. The captain was drowned soon after the vessel struck and three men froze to death while lashed to the rigging. . . . The *Castagna* was torn to pieces early Friday. . . . At dawn Saturday, after an all-night gale, the vessel had disappeared from the outer bar, while her flotsam was being hurled onto the beach from the Pamet River to Nauset Lights."

A few surviving Italian sailors were brought to the Marconi Wireless Station in South Wellfleet, where the women of the station had hot coffee and food waiting for them. It was from there that, only a few years earlier, Marconi had made his historic wireless transmission from America to Europe.

Wellfleet has been the muse for the imaginations of many artists and writers. Edward Hopper painted the *Bluff Cottages at Mayo's Beach* in 1933. One of the central stories in Henry Thoreau's classic book *Cape Cod* tells of an unforgettable night Thoreau spent in 1849 at the house of the "Wellfleet oysterman," John Newcomb. The oysterman's house still stands above Williams Pond, one of Wellfleet's many glacial ponds. In silent pilgrimage, I paddled the three connected jewels of Gull Pond, Higgins Pond, and Williams Pond to see the house. I imagined Thoreau inside listening to Newcomb tell his tales while spitting tobacco juice into the fire.

Along the wild Wellfleet beaches and on the country roads and narrow village streets, I see folks walking with perpetual half smiles on their faces. They appear to be keeping some mysterious secret. It may be something handed down from the days when Cape Codders sailed more often to Asia than to Boston. Their ancestors may have brought back more than whale oil and spices from the East, a capacity for ineffable reverie. Or perhaps their Zen smiles are only a natural reaction to a blue sky, beach roses, and the way the air holds the salt and sweet scent of locust.

The calm elders I so often see gazing out to sea seem ageless. They watch the tides, they hear the waves, and they think of time. Someone once noted that the rhythmic shushing of waves is a deep, unconscious reminder of the sound of our mother's heartbeat as we floated in the womb. We came from the sea and, like Billingsgate Island, like Wellfleet, and like all of Cape Cod, we return to the sea.

One

THE PUNANOKANITS AND THE FIRST EUROPEANS

"In the beginning there was nothing but sea-water . . ."
—Native American Legend

WELLFLEET, A CLASSIC CAPE COD SEASIDE VILLAGE. Its Congregational Church still sits on a hill overlooking the harbor. Its steeple clock strikes the hours in eight bells, according to ships' time, as boats go out to harvest famous Wellfleet oysters. But long ago, before the Pilgrims first saw Wellfleet Harbor and before Champlain gave it its first European name, there were the Punanokanit Indians, whose bones occasionally rise to the surface of Wellfleet's sandy soil.

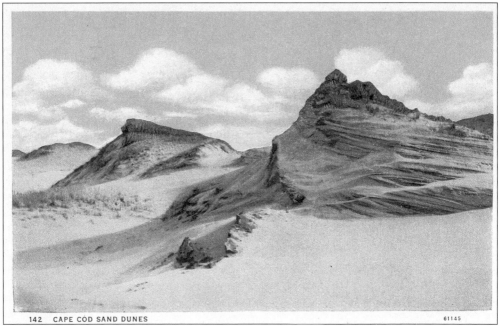

142　CAPE COD SAND DUNES　　　　　　　　　　　　　　　　61145

A WAMPANOAG TRADITION. "In the beginning there was nothing but sea-water on top of the land. Much water, much fog. Also Kehtean, the Great Spirit, who made the water, the land under it, the air above it, the clouds, the heavens, the sun, the moon, and the stars. Kehtean dwelt in the Spirit Land, in the Western Heavens. . . . Once Kehtean left the Western Heavens, came to the world, and passed over the waters that covered it. He reached down to the bottom of the sea, took a grain of sand and of that made the earth. He created four guiding spirits to guard the four corners of the earth; and he made four winds. Then he made animals in the likeness of spirits of earth and heaven, birds in the likeness of the four wind-spirits, fish in the likeness of the Water Spirit . . . and he gave life to them all." (Elizabeth Reynard, *The Narrow Land*, Boston: Houghton Mifflin, 1934, pp.23–24.)

OLD CAPE COD
THE LAND OF HEART'S DESIRE

Did you ever go down on Old Cape Cod,
That place that speaks of peace
 and GOD,
Where the trees, and flowers and
 even grass,
Nod you a welcome as you pass,
Where you hear the waves a-
 pounding the shore,
When the wind's nor'east and the
 storm clouds lower;
Where you breathe in the smell of
 the old salt grass,
As on the highway of God's
 country you pass.
No place in the world shines the
 sun so bright,
Or the moon when it's full on a
 summer's night,
And the people "God bless them,"
 that true do they ring
They make you as welcome as the
 flowers in Spring,
A hand clasp that thrills way down
 to the toes,
Is the greeting one gets wherever he goes.
Just to think of that place is to me,
With its wonderful flowers and
 sky and sea,
Like sweetest nectar, fit for a god,
That I drink to the health of Old
 Cape Cod. JOHN CHIPMAN

120 AN OLD CAPE COD HOUSE 108008

HOW MAUSHOP MADE THE DUNES AND HOLLOWS. "Years ago, in the days before the first white people came across the sea, a young giant named Maushop lived in the Narrow Land. He was so large that no wigwam nor Council House could hold him, so he slept under the stars. Sometimes he lay on one part of the Cape, sometimes on another. To him snowdrifts were like handfuls of beach-sand and wrapped in his robe of many hundred bearskins, the heat from his body kept him warm in the cold winter weather. If he awakened on an icy night . . . he warmed himself by jumping back and forth across-cape. In summer he could not sleep when the heat of the land grew oppressive. On such nights he made a bed of the lower Cape; of the cool lands that lie narrowly between ocean and bay. There his body twisted and turned, changing position, seeking repose, until he shifted the level sand into dunes and hollows." (Elizabeth Reynard, *The Narrow Land*, p.26.)

11

143 CAPE COD SAND DUNES 111728

A Surprising Discovery. Dan Carns noticed something odd in the eroded dunes of Coast Guard Beach as he walked the shore in November 1990. Over the next two years, archaeologists uncovered the dwelling site of a people who lived in the area that we call Wellfleet between 7,500 and 7,700 years ago. Remains of hearths, stone arrowheads, and pottery told the story of two periods of habitation. Many of the cooking and storage pots were made in a more recent period—nearly 2,500 years ago.

Slow Turtle (John Peters), a Full-blooded Wampanoag Medicine Man. In 1979, a backhoe operator working on William Connelly's land at Indian Neck thought he had uncovered the bones of a horse or a cow. As more bones surfaced, he got off his machine to see a tooth-filled human jaw. An archaeological dig followed, revealing a mass Native American grave site, or ossuary, dating back 1,000 years. At least 56 men, women, and children were found. They had lived there year-round, as did others around Nauset Marsh and Wellfleet Harbor, surviving on deer, acorns, shellfish, waterfowl, and other wild foods.

12

WAMPANOAG TRIBAL ELDERS AT THE GREAT ISLAND CEREMONY. In 1976, members of the Wampanoag Nation and the Wellfleet Historical Society reinterred the remains of a 16th-century Wampanoag woman in a sacred ceremony on Great Island. Her body had been discovered during a house excavation in Wellfleet in 1953. At the burial ceremony, the following was said: "Small Indian woman, we cannot restore you, like Lazarus, to life but we can release you from the indignities of exhibition and return you to the elemental dignity of death . . . rest now in the sweet privacy of this grave."

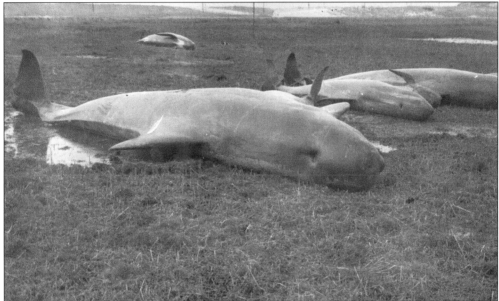

PILOT WHALES ON THE MARSHES OF SOUTH WELLFLEET. The Punanokanits who inhabited Wellfleet in the late 16th century, were among the Wampanoag tribes. It was from such tribes that Europeans first learned to hunt whales on Cape Cod. They had been harpooning whales or driving pilot whales, also known as blackfish, ashore. In his journal of 1605, George Weymouth wrote, "when they have killed him & dragged him to shore, they call their chief lords together, & sing a song of joy; and those chief lords, whom they call Sagamos, divide the spoil, and give to every man a share." A smallpox epidemic, brought by the whites, devastated the Native-American population *c.* 1615. By 1620, only about 100 Punanokanits lived throughout Wellfleet.

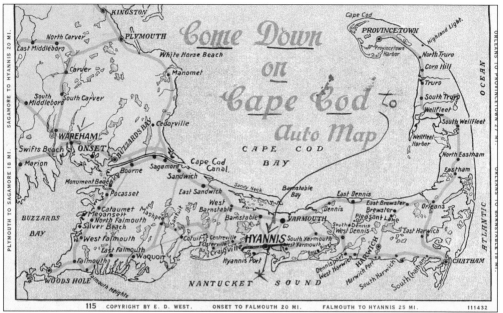

COPYRIGHT BY E. D. WEST. ONSET TO FALMOUTH 20 MI. FALMOUTH TO HYANNIS 25 MI. 111432

A PICTURE POSTCARD AUTO MAP OF CAPE COD, 1920s. More than 300 years before summer tourists converged on the Cape, French explorer Samuel de Champlain sailed into Cape Cod Bay. In search of a warmer climate than the French colony to the north, he first saw Wellfleet Harbor in the summer of 1605. On a second expedition in the fall of 1606, Champlain, observing the abundance of oysters, named the harbor Port aux Huites—Oyster Harbor.

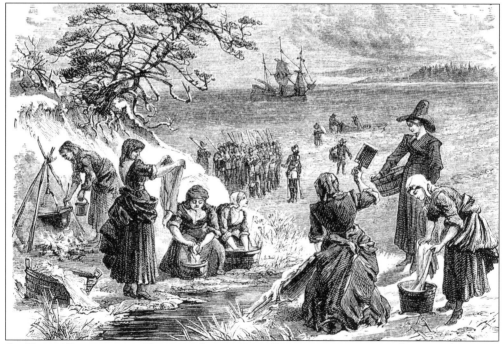

AN EARLY PRINT OF THE PILGRIMS LANDING AT PROVINCETOWN. In early December 1620, the Pilgrims set off from Provincetown on their final exploration of the Cape before going to Plymouth. It was then that they first saw what is now Wellfleet.

14

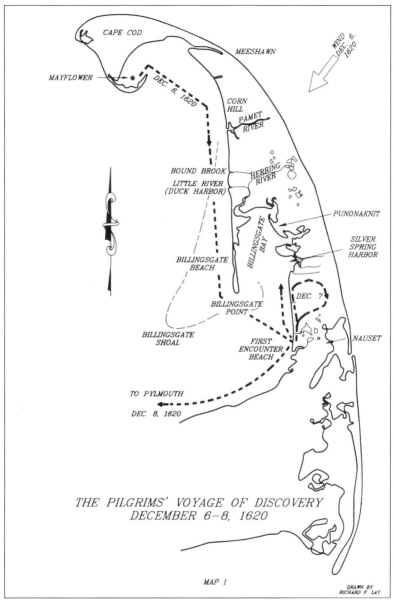

THE PILGRIMS' VOYAGE OF DISCOVERY
DECEMBER 6–8, 1620

MAP 1

DRAWN BY
RICHARD F. LAY

THE PILGRIMS' VOYAGE OF DISCOVERY, DECEMBER 6–8, 1620, FROM DURAND ECHEVERRIA'S A HISTORY OF BILLINGSGATE, WELLFLEET HISTORICAL SOCIETY, 1993. A contemporary description by "George Mourt" follows: "Wednesday, the 6th of December, we set out, being very cold and hard weather . . . two were very sick, and Edward Tilley had like to have sounded with cold. The gunner also was sick unto death . . . the water froze on our clothes, and made them many times like coats of iron." Among the men were Myles Standish, John Carver, William Bradford, Edward Winslow, John Howland, Richard Warren, and Stephen Hopkins. "We sailed six or seven leagues by the shore, but saw neither river nor creek. At length we met with a tongue of land, being flat off from the shore, with a sandy point [later called Billingsgate Beach, extending from Great Island]. We bore up to gain the point, and found there a fair income or road of a bay, being a league over at the narrowest, and some two or three in length [Wellfleet Harbor]."

15

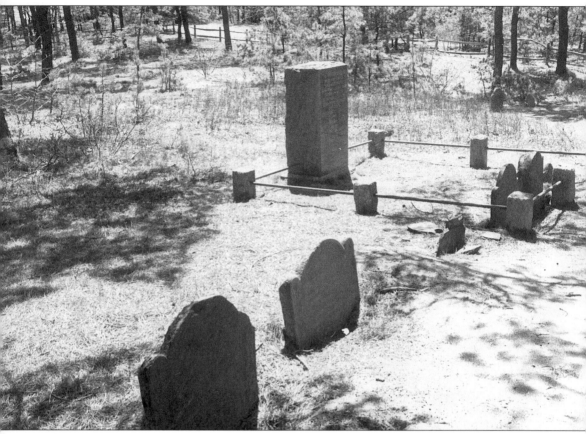

THE CHEQUESSETT NECK CEMETERY. In 1645, purchasers from Plymouth were granted the land for what are now Orleans, Eastham, and Wellfleet. After 1710, Wellfleet, then known as Billingsgate, had enough settlers to require a separate church. In 1714, Josiah Oakes was brought from Boston to preach at Chequessett Neck. A small meetinghouse and cemetery existed by 1719. In 1721, Oakes was appointed full-time minister and a Church of Christ was formally established. On this same hill, Punanokanit Indians are buried. Work on a nearby cottage in the 1940s revealed the bones of an adult male with an arrowhead in his spine, bundled and buried with his knees drawn up to his chin. With him was found the skeleton of a female child.

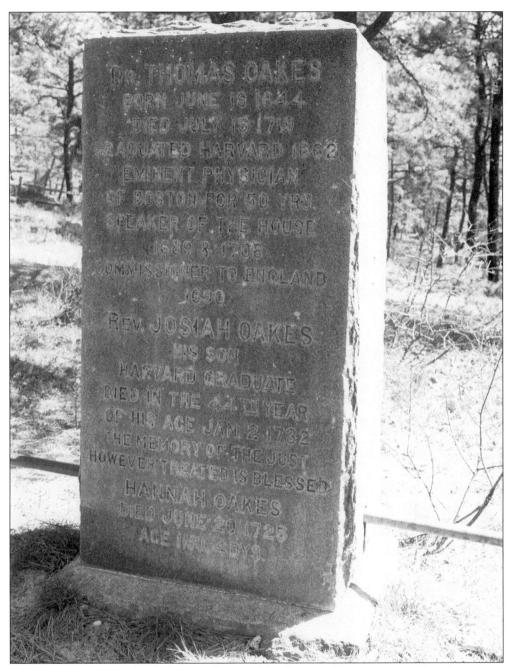

THE GRAVESTONE OF REV. JOSIAH OAKES, HIS FATHER THOMAS, AND HIS DAUGHTER HANNAH. In August 1724, Margaret Hough, cousin of church founder John Doane, became pregnant. The Reverend Oakes married her the following November and then on May 16, 1725, Hannah Oakes was born. Billingsgate residents accused Oakes of "fornication and scandalous works." Hannah died of unknown causes one month and four days after her birth. A legend still circulates that Hannah had been born with Down's syndrome and that Oakes had performed a mercy killing. Her spirit, some say, floats through Wellfleet on foggy evenings in search of her father.

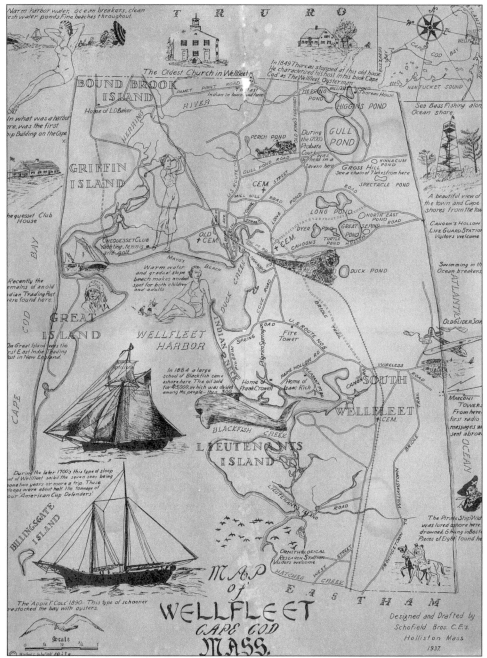

A 1937 MAP OF WELLFLEET. In 1763, Billingsgate was set off from Eastham as a district, taking on most functions of an independent town. It was then that Billingsgate became known as Wellfleet. The district of Wellfleet officially became a town in 1775. By that time, few Punanokanits survived. In 1764, 11 were counted and by 1792, there were fewer than half a dozen. Their history recedes into myth. Delilah Sampson Gibbs, the last Wellfleet Indian, died some time after 1838. Little is known of her. She grew peaches and had "a fine gift of profane declamation," according to one contemporary. Others said that Delilah was the incarnation of the Sea Witch of Billingsgate.

Two
THE HARBOR

Oh a wet butt
And an empty gut
The fisherman's life is rosy,
And mackerel are where you find them.
—Early Sea Chantey

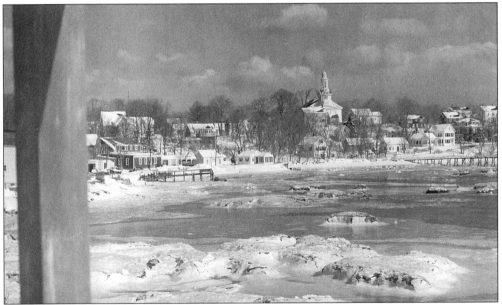

WELLFLEET, WITH THE CONGREGATIONAL CHURCH, AND UNCLE TIM'S BRIDGE ON THE RIGHT. Wellfleet Harbor is one of the most beautiful harbors in New England. It is a sheltered place where generations experienced hard fishing lives, a place of sail lofts, oyster sheds, old taverns, lighthouses, shipyards, and windmills. In the early morning when the lobster boats go out or at low tide when the oystermen are seen far out on the flats, time seems insignificant. (Photograph by Stimpson Hubbard.)

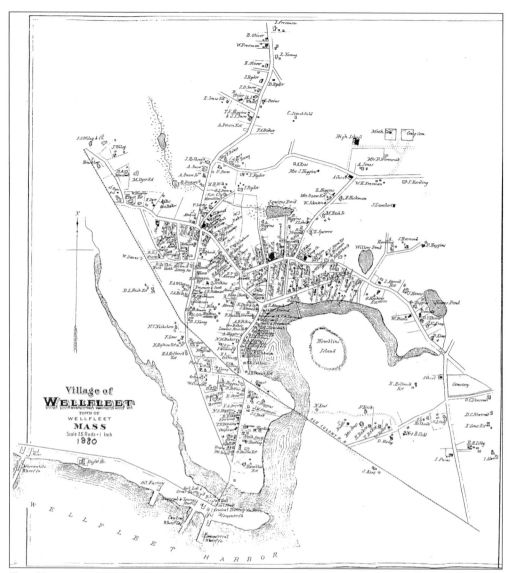

THE VILLAGE OF WELLFLEET, FROM THE ATLAS OF BARNSTABLE COUNTY, MASSACHUSETTS, GEORGE H. WALKER & COMPANY, BOSTON, 1880. Wellfleet's original name of "Billingsgate" came from a London fish market, which had been in operation since 1464. No one knows precisely from where the name Wellfleet came. Many towns in England have the "fleet" ending, from the Anglo Saxon *floet* or *flete*, meaning a place where the tide comes in. Some say it is a contraction of "whale fleet," referring to the whaling ships that sailed from the town's harbor. The name most likely derived from the Wallfleet oyster beds, near the River Crotch in Essex, England.

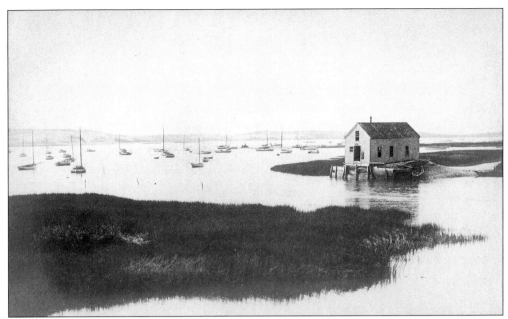

WELLFLEET HARBOR AT SHIRT TAIL POINT, LOOKING TO THE SOUTHWEST AT THE MOUTH OF DUCK CREEK. This is the site of today's Wellfleet Marina and Town Pier.

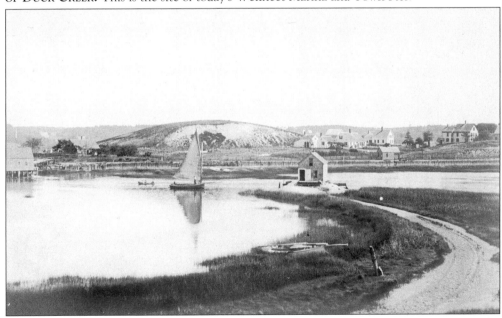

SHIRT TAIL POINT, LOOKING EASTWARD, C. LATE 1800S. The town's deepest and safest anchorage for ships was within Duck Creek until the railroad dike cut off access in 1870. Wellfleet was a major whaling port before the American Revolution. Over the years, 420 sailors and 20 or 30 vessels set sail from here, starting out in the spring for the West Coast of Africa. Wellfleet ships often called at St. Thomas in the Virgin Islands to replenish supplies before returning to homeport. Jesse Holbrook killed 52 whales on a single voyage and was later hired by a London company to teach the art of whaling. Hezekiah Doane owned 16 whalers, and whaling made Col. Elisha Doane one of the richest men in Massachusetts.

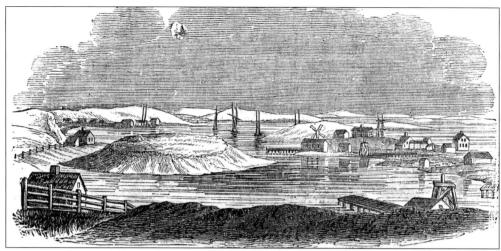

NORTHERN VIEW OF WELLFLEET HARBOR, 19TH-CENTURY COLORED ENGRAVING. During the American Revolution, the British blockaded Cape Cod ports. Some Wellfleet men died on prison ships, and some families moved to Penobscot and other places. The whaling fleet here deteriorated and with little capital, Wellfleet couldn't afford to rebuild it after the war. By 1802, only five whaling schooners were left. Later, in 1835, Paine Atwood and Elisha Perry built Commercial Wharf as the town recovered.

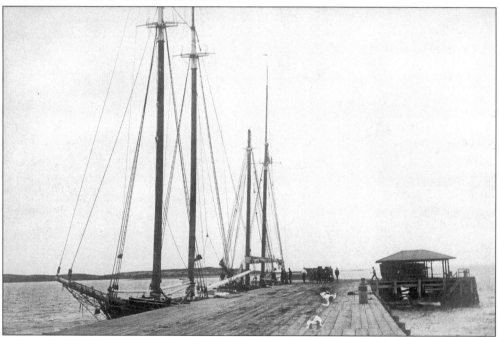

COMMERCIAL WHARF, AT THE SITE OF TODAY'S TOWN PIER. Wellfleet's first wharf was built before 1720 at Griffin Island. Ships from the West Indies off-loaded cargoes of sugar, molasses, and other staples, to be hauled away by oxcart. As sand shifted and closed in Griffin Island, Bound Brook Island, and Great Island, the population shifted to Duck Creek. Island houses were floated by barge to new sites. Some were "flaked," or cut into pieces like fish, before oxen hauled them overland. Only Billingsgate Island remained separate, with its village and lighthouse—until the island washed away in the 20th century.

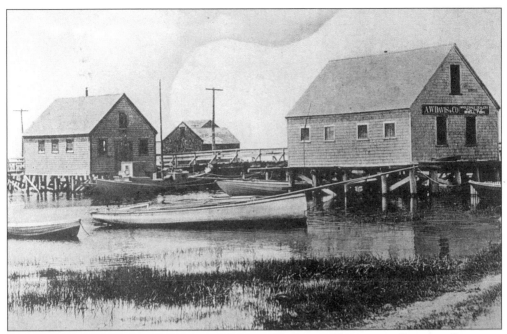

HIGGINS OYSTER SHED, LEFT, AND THE ALBERT W. DAVIS WHOLESALE SCALLOP COMPANY AT THE MOUTH OF DUCK CREEK, C. 1900. By 1837, Wellfleet had become a highly successful cod and mackerel fishing port. In that year, 39 boats and 496 men sailed from the first wharf, built here by John Harding c. 1830. Throughout the 19th century and into the 20th, mackerel, cod, oyster, scallop, and quahog sheds lined the shores of Wellfleet Harbor.

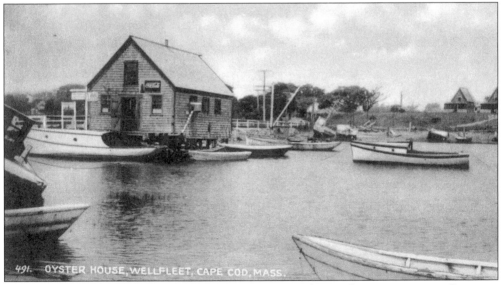

THE MARSHALL AND EVERETT HIGGINS SHELLFISH SHOP, SEEN FROM THE OPPOSITE DIRECTION AFTER THE REMOVAL OF THE ALBERT W. DAVIS SCALLOP COMPANY. Davis's shed became a blacksmith shop at the harbor and was later moved to Drummer's Pond in South Wellfleet. Davis hired out as manager of the Seal Shipped Oyster Company. Over the years, Higgins Shellfish Shop became more colorful—in appearance and history. In 1959, it was moved across the road and can still be seen in the middle of the Captain Higgins Restaurant.

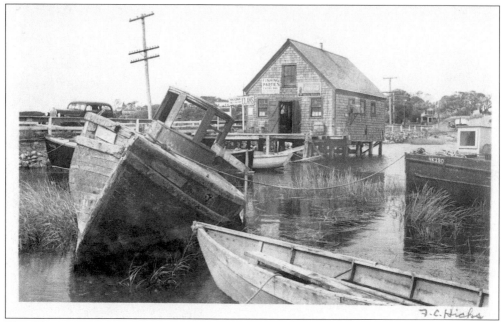

THE "SPIT AND CHATTER CLUB." The Higgins Shellfish Shop was one of the last of the old oyster shacks in Duck Creek. It became a place where the men who shucked oysters, quahogs, and razorfish gathered to socialize. There, men such as Lew Hatch, Commie Brown, and Sim Wiley told tales of the sea, while occasionally spitting in the sea's direction. Everett Higgins's shop became known as much for its "Spit and Chatter Club" as for being the place to buy clams and oysters, have a Coke, or launch a fishing party.

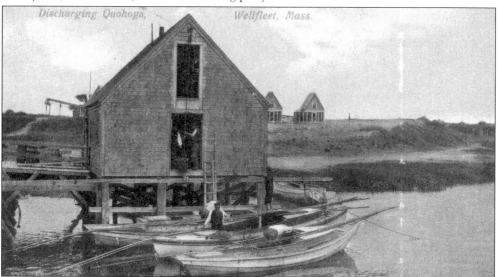

CAPT. FRED SNOW. Captain Snow watches while quahogs are unloaded at the A.W. Davis building at Duck Creek. He spent 37 years sailing the seas, carrying bananas from the island of Jamaica to Boston; oysters from Norfolk, Virginia, to Boston; coal from Philadelphia to Boston; and lumber from Maine to ports all along the East Coast. After selling his first schooner, the *Merrimac*, he owned the *Pleiades*. Snow learned that the *Merrimac* was later lost with all hands in the Gulf of Saint Lawrence. (N.S.)

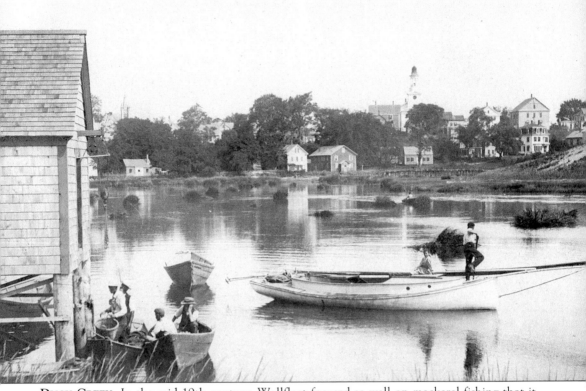

Duck Creek. In the mid-19th century, Wellfleet focused so well on mackerel fishing that it shipped more than did Provincetown. Its three harbors, at Duck Creek, Herring River, and Blackfish Creek, could hardly contain the mackerel schooner fleet. Businesses on shore—the riggers, caulkers, salt makers, and barrel makers—prospered as well. Many owned shares in the vessels and supplied the fishermen's families with provisions while the ships were out. Skilled cooper Henry DeLory came to Wellfleet from Nova Scotia at the height of the mackerel fishing period. His watertight barrels were in high demand for shipping iced and salted mackerel. Many "herring chokers" from Nova Scotia were welcomed into the community. When part of DeLory's roof blew off in a gale on his family's first night in their Commercial Street house, the townspeople turned out the next morning to repair it.

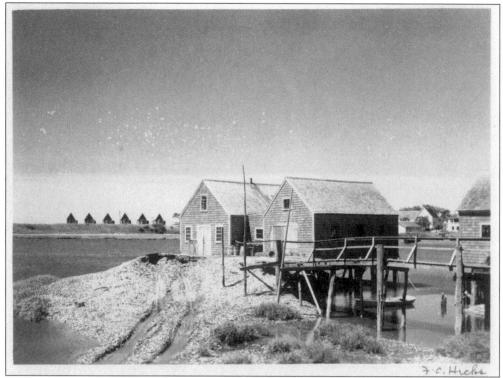

OYSTER HOUSES AT THE RAILROAD DIKE, DUCK CREEK. Wellfleet has always been known for its succulent oysters. After the coming of the railroad in 1870, the industry boomed. Oysters could leave Wellfleet Harbor and be eaten in Boston or New York within hours. Oyster houses like these were built nearby the railroad station on Commercial Street. "Nearly all the oyster shops and stands in Massachusetts, I am told, are supplied and kept by the natives of Wellfleet." —Henry Thoreau, *Cape Cod*, 1865.

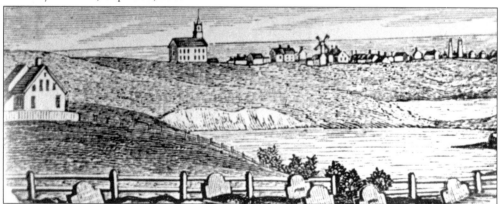

THE CHEQUESSETT NECK CEMETERY. The cemetery on Taylor Hill looks out on the harbor and its windmills in this rare print made before 1839. Long forgotten now are the windmills that were scattered around the bay in the first half of the 19th century. Hardly like the picturesque windmills on Mill Hill, these were bare machines that pumped seawater into vats, which evaporated tons of salt for curing fish. The Salt Manufacturing Company of Billingsgate was formed in 1821. By 1837, a total of 37 saltworks were operating in Wellfleet, run by men such as Isaac Baker, David Atwood, Deacon Whitman, and Cornelius Hamblen. (N.S.)

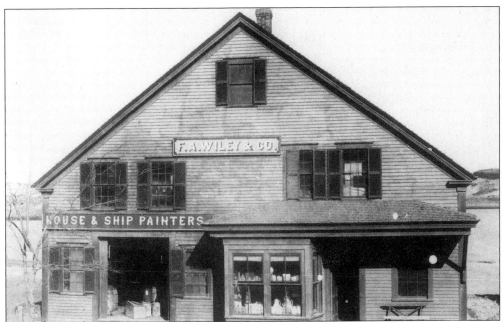

F.A. WILEY & COMPANY, HOUSE & SHIP PAINTERS. Many businesses were built on Commercial Street to serve the town and the fishing fleets. F.A. Wiley, located where a lumberyard stands today, dealt in groceries, tobacco, stationery, and drugs. The company painted both houses and ships and advertised the sale of "paints, oils, glass, and brackets." (N.S.)

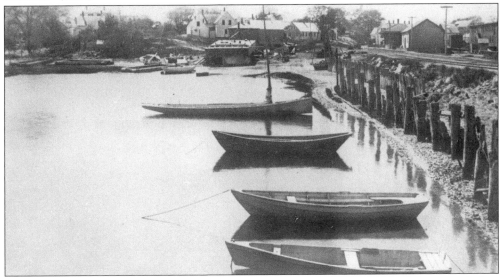

SHIPYARD IN DUCK CREEK, 1908. Wellfleet was one of the Cape's largest whaling ports before the American Revolution. The first documented whaling schooner built in Wellfleet was the *Freemason*, built on Bound Brook Island *c.* 1800 and owned by Capt. Reuben Rich. This Duck Creek shipyard was begun by Henry Rogers and Sons. From 1848 to 1853, the company built eight schooners, the *Simeon Baker*, the *J.Y. Baker*, the *J.S. Higgs*, the *Benjamin Baker*, the *R.R. Freeman*, the *I.H. Horton*, the *George Shattuck*, and the *Varnum H. Hill*. Another shipbuilder, Nathaniel Snow, built two sloops for Capt. L.D. Baker for the banana trade with Jamaica.

DUCK CREEK AND THE CONGREGATIONAL CHURCH. Hardworking fishing boats sometimes end their days slipping back into the mud of Duck Creek. Wellfleet ship owners often went to off-Cape shipyards when they needed the largest of vessels. The following is from the *Provincetown Advocate* of June 1, 1870: "The Messrs. Hawthorne & Hodgkins of Bath, Maine, are at work upon a large 3-masted schooner of full 675 tons burthen. The model is well suited for carriage and sailing qualities. This vessel was contracted for by Mr. E.A. Atwood, agent of Wellfleet, and is to be commanded by Captain Pervere, of the same vicinity. The frame is of native white oak and yellow pine. The dimensions are 145 feet on deck by 32 feet beam . . ."

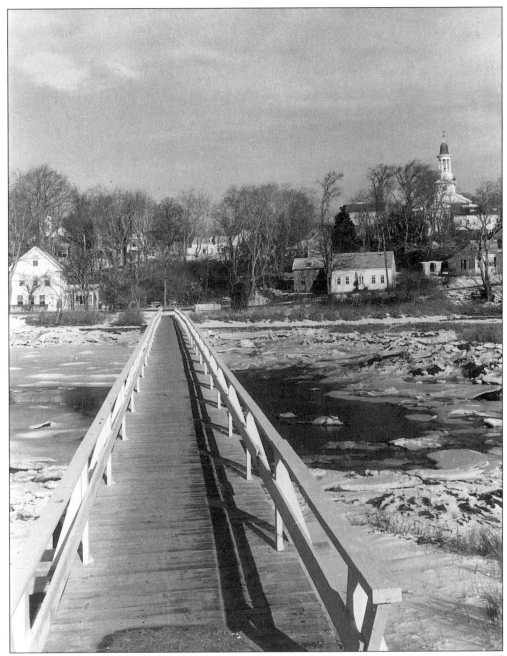

THE BRIDGE. Uncle Tim's Bridge connects Hamblen Island (also known as Cannon Hill) to the village. This often photographed, often painted bridge was named for Timothy A. Daniels, who died in 1893 at the age of 86. The building on the left housed Uncle Tim's ships' chandlery.

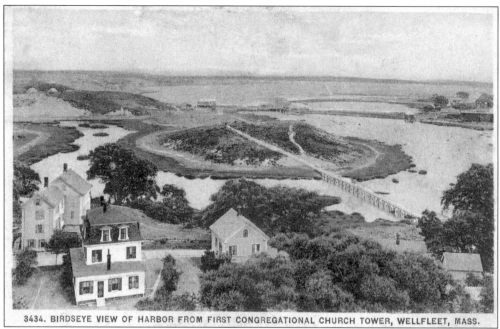

3434. BIRDSEYE VIEW OF HARBOR FROM FIRST CONGREGATIONAL CHURCH TOWER, WELLFLEET, MASS.

HAMBLEN ISLAND AND UNCLE TIM'S BRIDGE. Seen from the opposite direction, this image was taken from the steeple of the Congregational Church on Main Street. The following appeared in the *Provincetown Advocate* of March 14, 1871: "Messrs. Taylor, Campbell, and Brooks of East Boston are building a 3-masted schooner of 700 tons. She is of fine proportions, and every part of her construction is as perfect as possible. She will hail from Wellfleet. The same firm are also building two other schooners for Wellfleet, of respectively 130 and 100 tons."

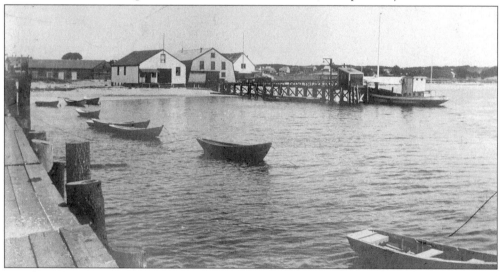

THE SEAL SHIPPED OYSTER COMPANY, C. 1910. The original oyster beds mysteriously died out *c.* 1770. In the early 1800s, nearly 40 schooners brought seed oysters from the Potomac River to mature in Wellfleet waters. After taking on the unique flavor of a Wellfleet native oyster, they were shipped in huge quantities to major cities. After the start of the 20th century, the Seal Shipped Oyster Company sent huge quantities of famous Wellfleet oysters out across the United States and Canada.

30

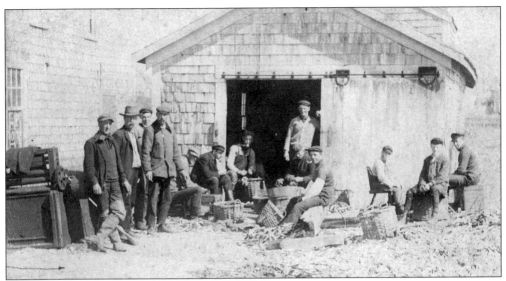

THE RAZORFISH GANG AT CENTRAL WHARF, 1912. In the cold winter months, barrel maker Henry DeLory and his "gang" supplemented their income by digging razor clams. These clams (also called razorfish) got their name from their similarity to the handle of a straight razor. DeLory, seen in the doorway, shipped the clams to Provincetown and Boston for fishermen to use for baiting their hand trawls. During Wellfleet's great mackerel fishing days of the 19th century, this building was used for the tarring of mackerel seines. (N.S.)

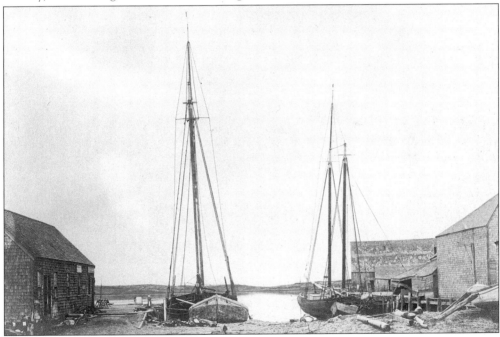

SHIPS AT CENTRAL WHARF. This wharf, built in 1863 to the west of today's Town Pier, was crowded with sail lofts, ships' stores, barrel makers, and a blacksmith. During Wellfleet's great oystering days, the Payne and Newcomb Sail Loft was converted by Ed Eldredge into a barrel factory. William Taylor began another barrel factory here as well, when demand for barrels to ship oysters reached 200 a day.

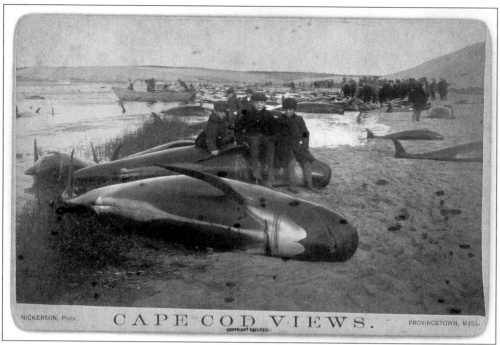

STRANDED IN WELLFLEET HARBOR. Pilot whales, known to Cape Codders as blackfish, used to enter Wellfleet Harbor every fall in great numbers. Up to 1,500 at a time would mysteriously beach themselves or be purposely driven ashore. The Wellfleet Blackfish Company's tryworks was located halfway between the Town Pier and the Mayo's Beach Lighthouse. Men stripped blubber from the whales and rendered it into oil at the tryworks. The "melons" of blubber in the head of each blackfish were most prized, for they rendered the finest watch oil. (N.S.)

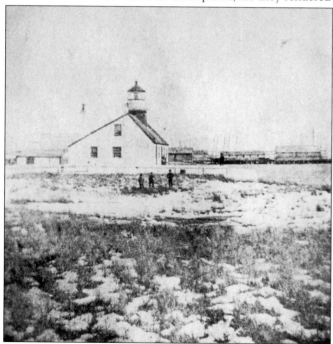

THE FIRST MAYO'S BEACH LIGHTHOUSE, BUILT FROM 1837 TO 1839. Once past the Billingsgate Light at the western edge of Wellfleet Harbor, ships looked for the light at Mayo's Beach, 40 feet above the sea. Joseph Holbrook was its first lighthouse keeper, followed by William Atwood in 1865. Raised in Wellfleet, Atwood went to sea as a boy. After losing an arm in the Civil War, he returned to Wellfleet and married Sarah Cleverly. Unable to return to the sea, he became a lighthouse keeper.

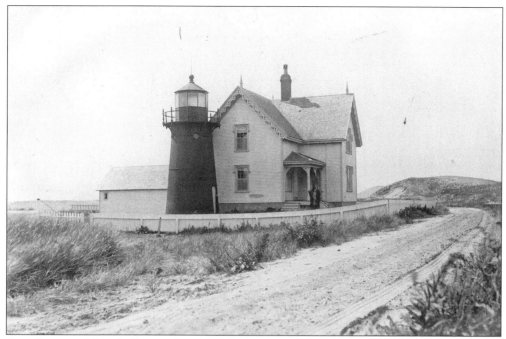

THE SECOND MAYO'S BEACH LIGHTHOUSE, BUILT FROM 1880 TO 1881. When William Atwood died in 1876, he left his widow, Sarah, and four small children. Sarah Cleverly Atwood became the first woman to be appointed a keeper by the Lighthouse Service. Her lighthouse, however, was deteriorating, and a new one was begun in 1880. Having kept the light burning in two lighthouses for a total of 26 years, Sarah Atwood resigned in 1891.

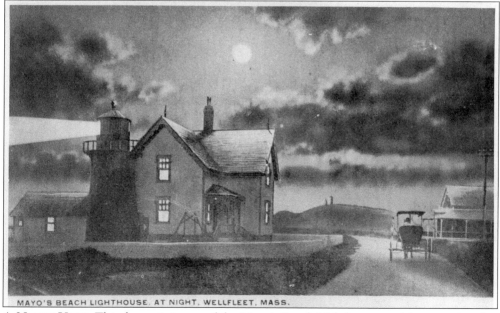

MAYO'S BEACH LIGHTHOUSE. AT NIGHT. WELLFLEET, MASS.

A NIGHT VIEW. This dramatic image of the Mayo's Beach Lighthouse at night was printed as a postcard, c. 1907.

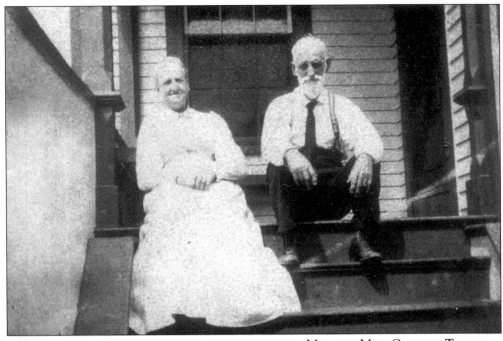

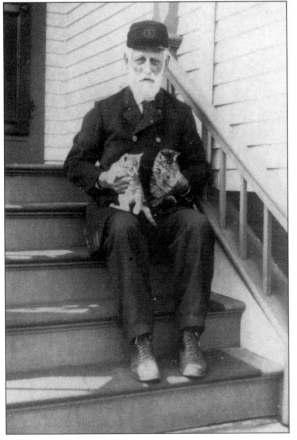

MR. AND MRS. CHARLES TURNER AT THE MAYO'S BEACH LIGHTHOUSE. Charles Turner followed Sarah Atwood as keeper of the Mayo's Beach Lighthouse. For 30 years, Turner climbed the spiral stairs to tend the light. Twice a year, the lighthouse tender *Mayflower* delivered kerosene to fuel the light. For safety, it was stored in a separate, small brick structure that still stands. Set among red and white beach roses, the little red building is a favorite subject for photographers and artists. (N.S.)

LIGHTHOUSE KEEPER CHARLES TURNER ON THE STEPS WITH THE LIGHTHOUSE CATS. Even more than lighthouses and cats, Turner loved boats. He was one of the town's most skilled builders of dories and sloops, working out of buildings at the foot of the Town Pier. He built Capt. Parker Hickman's sloop *Ethel E. Young, c.* 1900, and designed a popular style of dory that bore his name. (N.S.)

KEEPER OF THE MAYO'S BEACH LIGHTHOUSE CHARLES TURNER, POSING WITH HIS DAUGHTER BEFORE THE IRONCLAD LIGHT. On March 10, 1922, the lighthouse was discontinued, and the government sold it in 1923. The tower was torn down in 1939, but the house itself still stands on Mayo's Beach, with the kerosene house by the water. The cement circle of the lighthouse foundation is still visible. (N.S.)

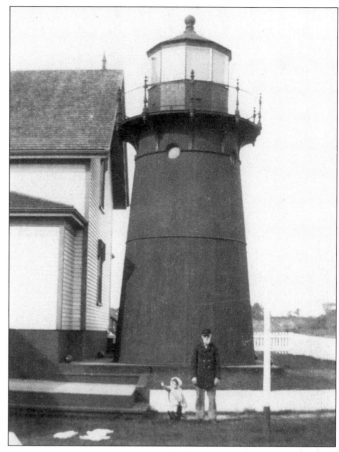

MERCANTILE WHARF, TO THE WEST OF THE MAYO'S BEACH LIGHTHOUSE. At the height of Wellfleet's cod and mackerel fishing days, some 100 vessels sailed from the harbor. In 1870, Mercantile Wharf, the last of Wellfleet's great wharves, was built to help accommodate them.

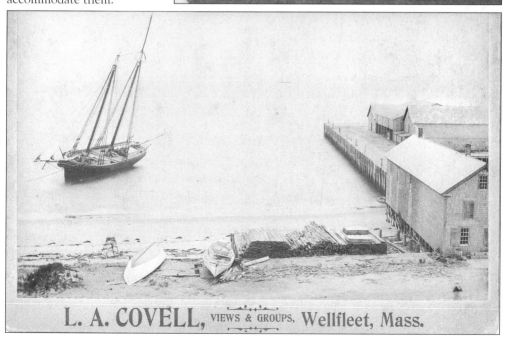

L. A. COVELL, VIEWS & GROUPS, Wellfleet, Mass.

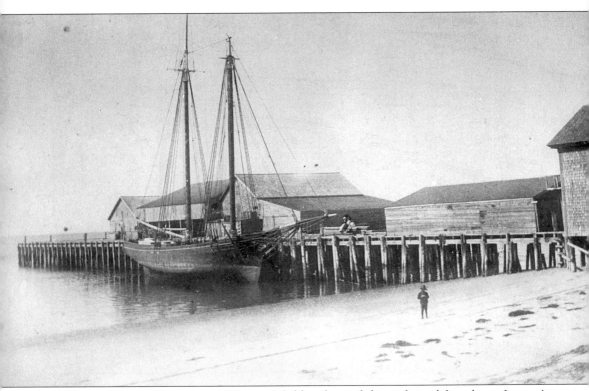

A YOUNG BOY AT MERCANTILE WHARF. Children learned the seafaring life early on. It wasn't uncommon in the 19th century for boys to go to sea by the age of 12, often as cooks. Capt. Nehemiah Newcomb began his career as a cabin boy on the fishing schooner *Telegraph* at the age of 9. George Baker began following the sea from Wellfleet in 1836, at the age of 13. Louis Hatch first shipped out at the age of 12, under Capt. Samuel Foster. For 15 years, mackerel were packed and shipped from Mercantile Wharf; then, after 1885, Lorenzo Dow Baker cleared the wharf and built his remarkable Chequessett Inn over the water. Today, all that remains are the rotted stumps of Mercantile Wharf visible at low tide.

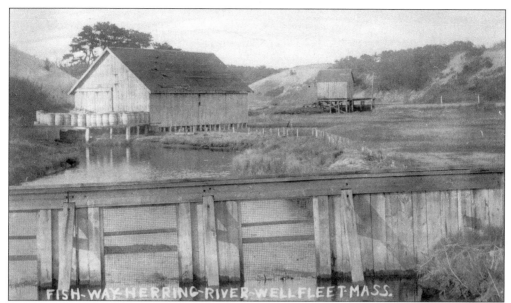

FISH WEIR AT HERRING RIVER. Each year the herring traveled up this river to spawn at Herring Pond, in the northeast part of town. Where the Herring River emptied into Wellfleet Harbor, the town owned a fish weir; each year the fishing rights and the use of the weir were sold to the highest bidder. (N.S.)

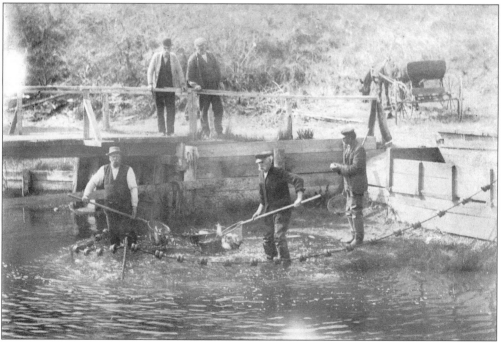

CATCHING HERRING ON THE HERRING RIVER. In 1896, Daniel F. Wiley was the highest bidder for the fishing rights to the river. He was obligated to open the gates to the pound to allow free passage of herring to their spawning grounds, and each Wellfleet family had the right to purchase from him 200 herring at a half cent each. Wiley bid enough for the fishing rights to more than cover the costs of the salaries of all town officials. (N.S.)

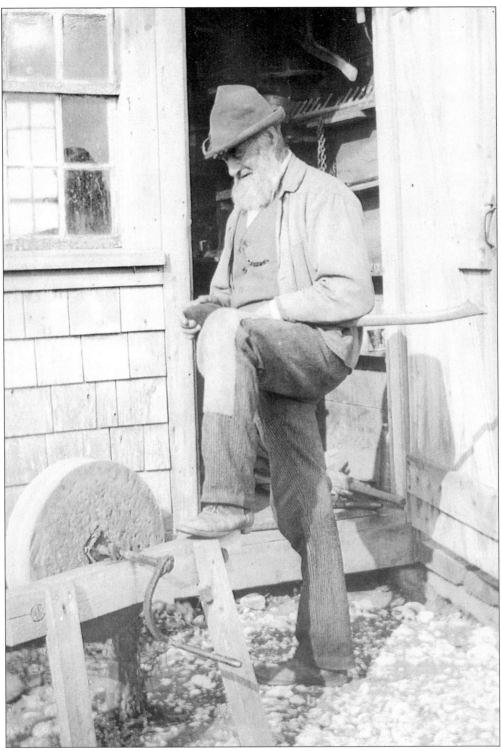

AT THE GRINDSTONE. A workman sharpens tools at one of the many workshops that once surrounded Wellfleet Harbor. (Photograph by Clifton Johnson.)

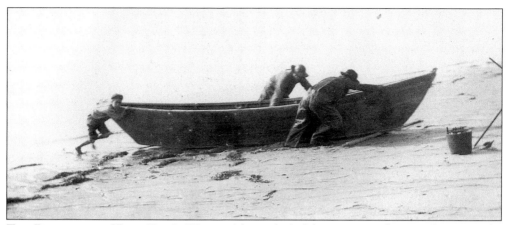

THE RESULT OF A HARD DAY'S WORK. After a day's fishing, a crew drags its dory onto the beach. (Photograph by Clifton Johnson.)

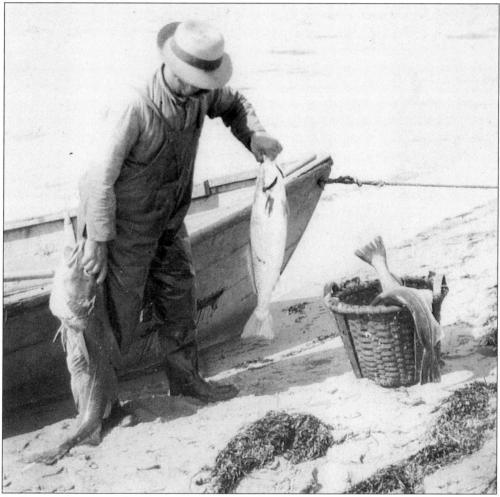

A PROUD DISPLAY. A fisherman shows off the day's catch of bluefish. (Photograph by Clifton Johnson.)

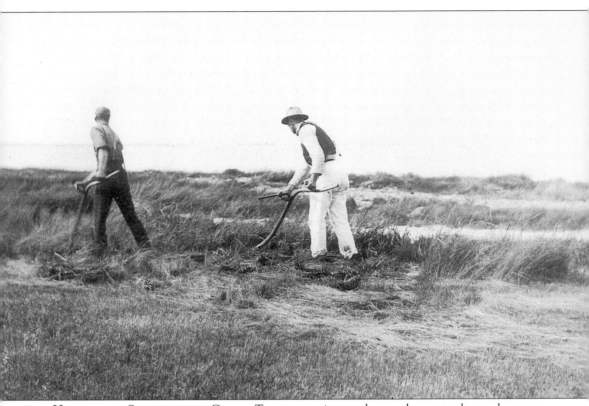

HARVESTING SALT-MEADOW GRASS. Two men swing scythes as they cut salt-meadow grass. Once a valuable crop, the grass supplied settlers with feed and bedding for cattle. (Photograph by Clifton Johnson.)

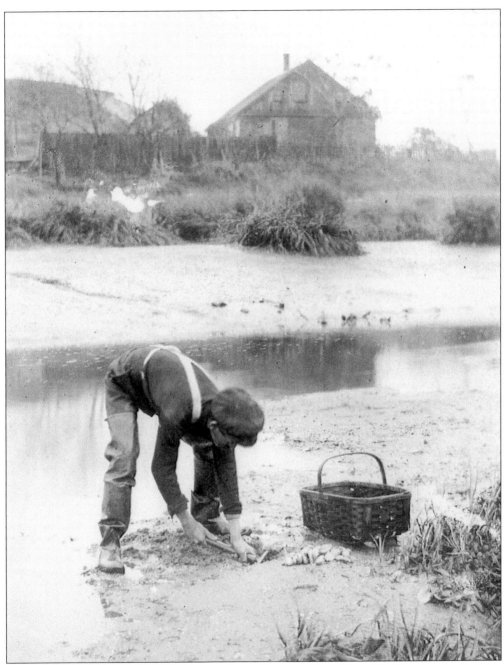

A Boy Digging in the Flats with his Clam Rake at Low Tide. Ned Lombard called this activity "scooming": "This, to the uninitiated, is the act of searching for shellfish, preferably barefoot and nearly as naked as one's nature or proximity to others permits. Any warm day is good, but for the most rewarding results, the sun should be shining and not a whisper of wind to blot out the many natural sounds of the flats. Wellfleet's shallow bay and sharp rise and fall of tides make it one of the greatest of places to pursue this pleasure. The end result of scooming is usually a full basket of shellfish . . ."—Edward E. Lombard, *I Heard the Ocean's Mighty Roar,* 1978. (Photograph by Clifton Johnson.)

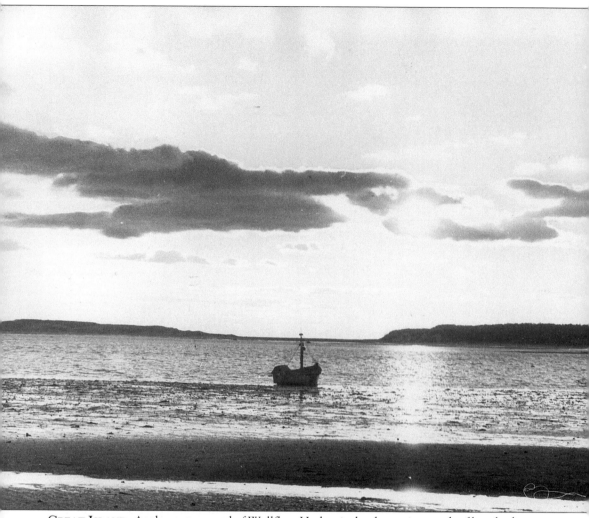

GREAT ISLAND. At the western end of Wellfleet Harbor is the dramatic stretch of beach, dunes, and forest called Great Island. Inhabited first by Native Americans, it is renowned for Smith's Tavern, a place where whalers gathered from about 1690 through 1740. It is said that the tavern keeper posted this sign on the island: "Samuel Smith, he has good flip, good toddy if you please, the way is near and very clear, 'tis just beyond the trees." In 1970 and 1971, archaeologists from Plimoth Plantation thoroughly studied the Smith Tavern site: "In its heyday, the whaler's tavern on Great Island must have buzzed with activity. The building sat just back from the edge of the sea cliff, and lookouts stationed on high points in the vicinity would have spotted whales in the bay." The archaeologists found fragments of wine bottles, an abundance of broken wineglasses, clam and oyster shells, whale bones, a harpoon shaft, a piece of scrimshaw carving, parts of a lady's ivory fan, and the frontal bone of a middle-aged man's skull, cleft by an axe.

Three
THE WELLFLEET
VILLAGES

This is one of the most thriving towns in the state. One of its former residents,
Colonel Elisha Doane, is said to have acquired a fortune of one hundred and twenty thousand
pounds sterling on this sandy spot.
—John Hayward's Gazetteer of Massachusetts, 1849.

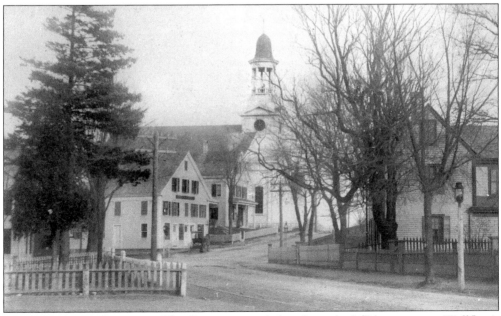

THE WATCHFUL NEIGHBOR. The Congregational church on the hill has overseen Wellfleet's
Main Street with simple dignity since 1850.

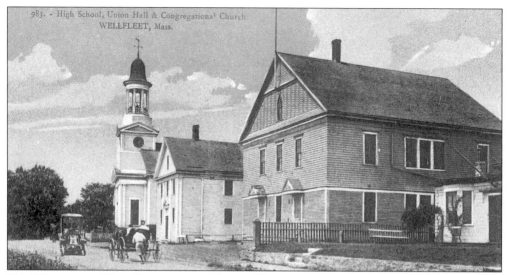

THE WELLFLEET HIGH SCHOOL, THE UNION HALL, AND THE CONGREGATIONAL CHURCH ON MAIN STREET, C. 1913. By the 1880s, the small populations of Wellfleet's outlying villages, such as Bound Brook to the north and Brook Village to the south, had begun to migrate to the center village. In 1889, the high school moved here from the intersection of School Street, Mill Hill Road, and the present Route 6 to Main Street.

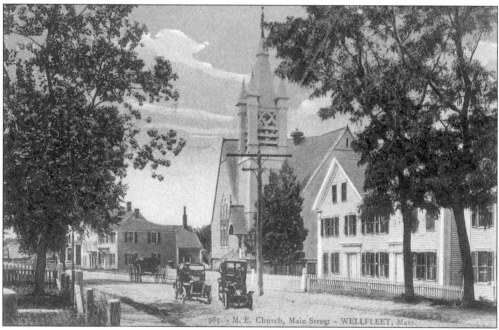

985. - M. E. Church, Main Street - WELLFLEET, Mass.

THE METHODIST EPISCOPAL CHURCH, MAIN STREET. Methodism had a powerful influence in Wellfleet. In 1802, Abigail Gross, Thankful Rich, and Lurana Higgins attended the first Methodist class meeting and in 1816, a church was built on Pleasant Hill, north of the village. After the great revivals of 1842 to 1843, a larger church was built on Main Street. In 1891, the new church was struck by lightning and burned, whereupon Lorenzo Dow Baker helped finance the building seen here. In more recent history, noted English artist Claire Leighton designed the stained-glass window that graces the church today.

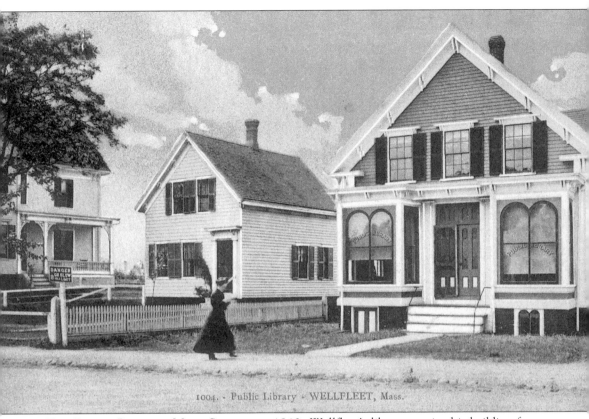

1004. - Public Library - WELLFLEET, Mass.

THE PUBLIC LIBRARY, MAIN STREET, C. 1913. Wellfleet's library was in this building from 1909 to 1956; for some time, Wellfleet's government was run on the second floor. Built in 1870 as the Payne Higgins Dry Goods Store, it is said that Payne Higgins had predicted the end of the world and gathered his family in a tree in front of the store. Passersby, using good Yankee reasoning, asked if Higgins would be marking down his prices. He replied, "Oh, no," and when the world survived, he and his family left their tree and continued business as usual. In the 1950s, Wellfleet historian Lydia Newcomb and other generous members of the community established the rich collections of the Wellfleet Historical Society here.

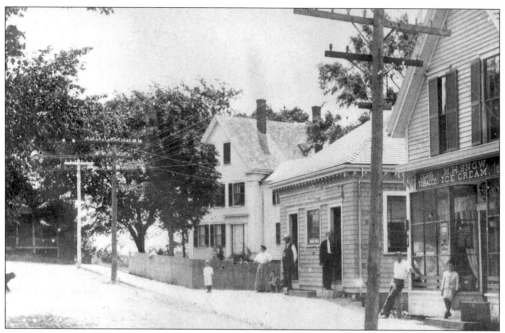

THE SPARROW HOUSE, POST OFFICE, AND SNOW'S ICE CREAM PARLOR, MAIN STREET, c. 1910. Though the Sparrow House is gone, Main Street still looks much like this. A thrift shop is now in the old post office, and a liquor store has replaced Snow's soda fountain.

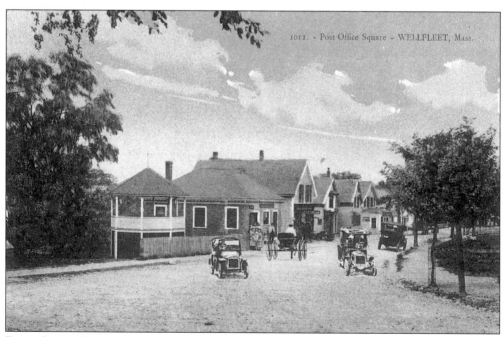

POST OFFICE SQUARE, MAIN STREET. The town bandstand was moved to the site of the Sparrow House by the 1920s. A shop replaced the bandstand, and a market (today the landmark Lema's Market) went in on the left at the corner.

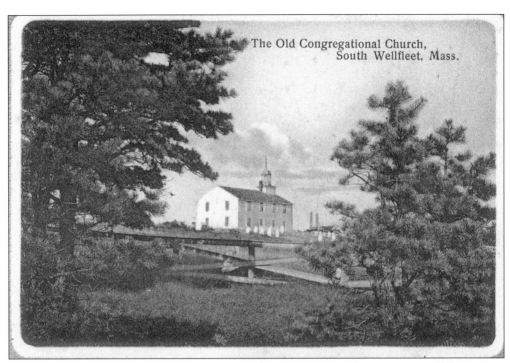

The Old Congregational Church,
South Wellfleet, Mass.

THE SOUTH WELLFLEET CONGREGATIONAL CHURCH, BEFORE 1913. In 1833, the Second Congregational Society built a church beside what is now the South Wellfleet Cemetery. In 1913, the church was bought by the Daughters of the American Revolution and moved to Main Street for use as a memorial hall. In 1941, this building became the Wellfleet Town Hall, with a town library established on the second floor. The historic building caught fire in the March blizzard of 1960 and was totally destroyed.

THE WELLFLEET TOWN HALL, REBUILT IN 1962. After the fire of 1960, a slightly altered reproduction of the old church-turned-town hall was built in 1962 on the same Main Street site.

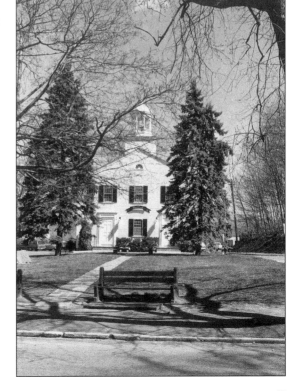

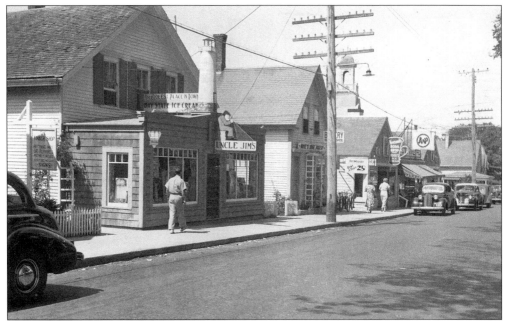

UNCLE JIM'S ICE-CREAM SHOP, MAIN STREET, C. 1940. Several buildings from Great Island, Bound Brook, and Billingsgate were moved into town in the late 1800s. The one on the left, from Great Island, served as the town post office in the 1890s. In 1907, J.F. Rich bought it and sold homemade ice-cream cones there for 2¢. After 1936, Harriet and Wilfred Costa opened the Ship's Bell Restaurant within the ice-cream shop. Since that time, a lighthouse has adorned the roof, and today the building is the unmistakable Lighthouse Restaurant.

THE ISAIAH YOUNG HOUSE, MAIN STREET. Bank president Isaiah Young provided his distinctive house in the center of town with a tower at the back to supply bathrooms with gravity-fed water. Old ship timbers incorporated in the structure creak with the memory of life on the sea. In the 1920s, this was the summer home of Massachusetts Gov. Channing Cox, who entertained many overnight guests, including Pres. Calvin Coolidge. The house was later used as Mrs. Brady's Boardinghouse, and it has been the convivial Aesop's Tables Restaurant since 1965.

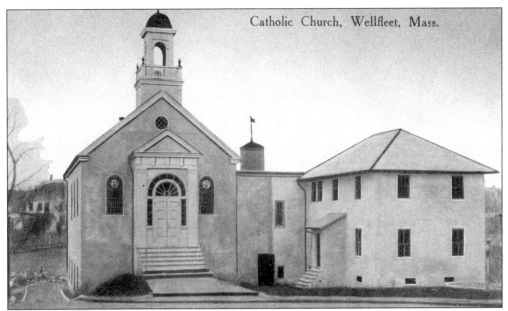

Catholic Church, Wellfleet, Mass.

OUR LADY OF LOURDES CHURCH, MAIN STREET, C. 1913. Catholics celebrated Mass in Wellfleet as early as 1877 in the homes of Joseph and Henry DeLory and Simon Berrio Sr. In 1900, Rev. Manuel Terra of St. Peter's Church in Provincetown bought and renovated an old Wellfleet schoolhouse for a church. In 1912 and 1913, Our Lady of Lourdes was built on Main Street, using windows from the earlier church. In 1975, Fr. Jude F. Morgan allowed two itinerant artists, Charles McCleod and John Kendall, to tent in the backyard. The men spent the summer and hand-carved dramatic and colorful front doors.

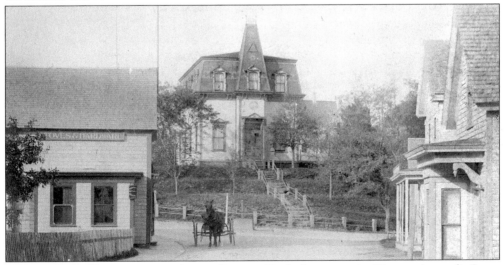

THE MASONIC TEMPLE OF THE ADAMS LODGE. Tucked up opposite Simeon Atwood's Stove and Hardware Store, this lodge originated in 1797, when Paul Revere signed charters for 23 lodges to be created in the state. Its mysterious blue-domed temple is filled with Arabic and medieval court motifs. With roots back to the stonemasons who built medieval castles, this secret guild was organized for protection from the whims of feudal lords. Though secrecy, symbols, and ceremonies are reminders of the medieval past, today's Masons do valuable charitable work.

49

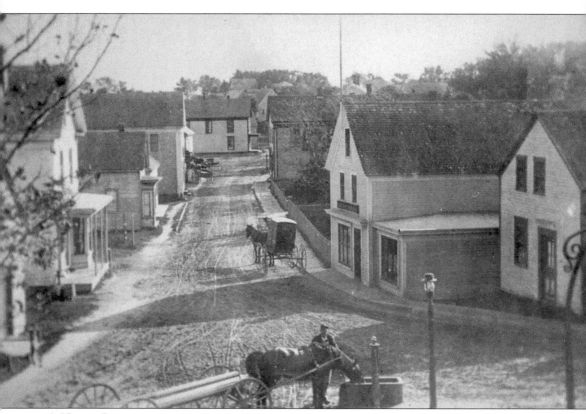

A Horse Drinking at the Town Pump on Commercial Street, Late 19th Century.
Simeon Atwood had his stove and hardware store on the right, in a building that today leans at a precarious angle. In 1878, the so-called Customs House was put in across the street from Atwood's. It was built for the Wellfleet Marine Insurance Company and not as a customs house. Atwood, the town's last deputy customs officer, probably did his customs work out of his house. He bought this place in 1905 and used it to store stoves. Further on the left was the large Sutton Hall, the first floor of which was Nathaniel Munroe's harness shop. This street was also home to a ship's chandlery, Everett Nye's blacksmith shop, the stagecoach relay station, and a wheelwright. Undertaker and stonecutter Oliver H. Linnel did business past Atwood's, on the right. Earle Rich remembered peeking through the windows as a boy at the sheet-covered forms of three victims of the Italian barque *Castagna*, which wrecked off Wellfleet in 1914.

WELLFLEET SAVINGS BANK BY THE TOWN PUMP AT BANK STREET, BUILT IN 1874.
Wellfleet's great days as a fishing port peaked between 1850 and 1870. Wharves from Duck
Creek to Mayo's Beach berthed hundreds of ships. South Wellfleet's Blackfish Creek alone held
100. Oil works and a wharf were built for whalers on Billingsgate Point. Amidst such prosperity,
Simeon Atwood Sr. helped establish the Wellfleet Savings Bank in 1863. He was a treasurer, a
director, and finally the bank president. As the town evolved into an artists' colony and resort,
the bank became the home and studio of artists Ethel Edwards and Xavier Gonzales.

THE ARBUTUS, HOLBROOK AVENUE. This storybook, carpenter Gothic-style house had been
abandoned at the Methodist Campground in Yarmouth. In 1900, Judge Hiram Harriman
moved it to Wellfleet for a summer home. The Harriman descendants have been using it as
such for generations. The *Barnstable Patriot* of July 21, 1902, reported that "The Arbutus has
been refurnished for the summer and Judge and Mrs. Harriman, Miss Harriman and maid are to
arrive Saturday, July 19."

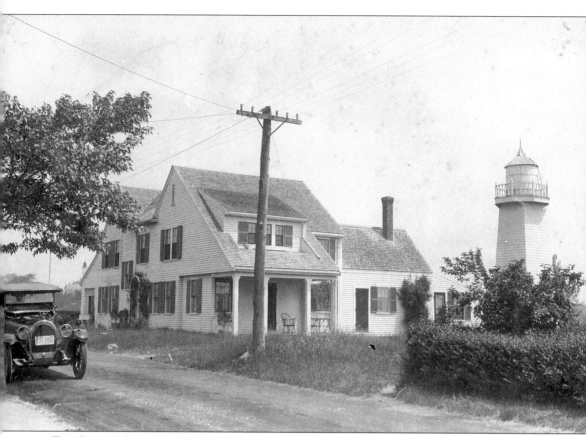

THE SIMEON ATWOOD HOUSE, EAST COMMERCIAL STREET. This striking house, barely visible today behind hedges, belonged to the remarkable Atwood family. Atwoods were in Wellfleet from the earliest days, and it was Simeon Atwood Sr. who, with Knowles Dyer, built the town's vital grocery and hardware store by the Town Pump in 1832. Packing several lives into one, he joined the state legislature in 1860, assumed the duties of deputy customs inspector for the port of Wellfleet the next year, and became a justice of the peace in 1865. He was a town moderator, a director of the Wellfleet Marine Insurance Company, the chair of the Republican Town Committee, the president of the Wellfleet Savings Bank, a church deacon, a choirmaster, and an organist.

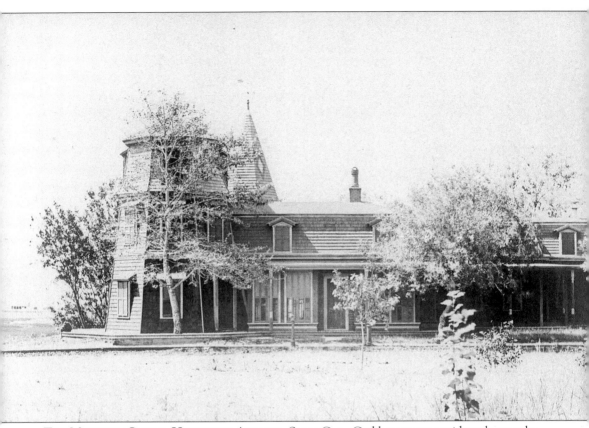

The Morning Glory, Holbrook Avenue. Some Cape Cod houses are accidental artworks. The Morning Glory is a mix of antique windmill, three mansard roofs, and a Queen Anne tower. The windmill had been built by Samuel Ryder on Mill Hill north of Squire's Pond in 1838. Ryder used timbers from an earlier 1765 mill and ground corn there until 1870, when a Mrs. Hiller bought the mill and moved it to Holbrook Avenue. When Elton Crockett bought the expanded place in 1944, he converted the two privies in the yard into a workshop. Modern plumbing and other changes followed. Present owners Bill and Phyllis Crockett marvel at the number of artists who have painted the place, and the stream of visitors who stop and gaze at the house of towers, stained glass, spiral stairways, trapdoors, and weather vane with two bullet holes.

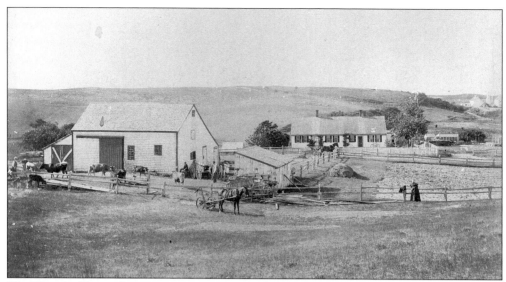

THE TAYLOR FARM, CHEQUESSETT NECK ROAD. This early-18th-century farm with its double Cape Cod house is one of the oldest in town. The land was originally a royal grant from the King of England to Daniel and Samuel Mayo, born in 1714 and 1718, respectively. The grant reached the shoreline of Wellfleet Harbor, at what is still known as Mayo's Beach. The salt marshes produced hay, stored for large herds of cattle in the barn across the road. In the 19th century, the Taylor sisters, Betsy and Laura, owned the place they called Freeman Farm when Betsy married John Freeman.

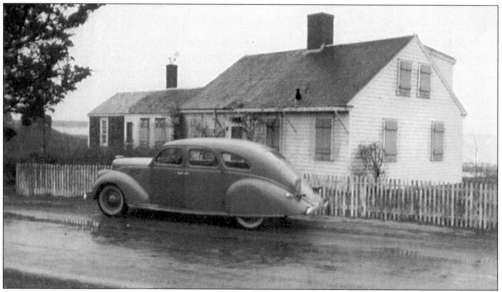

AUNT SUKIE'S HOUSE, CHEQUESSETT NECK ROAD, 1938. Susan Atwood, later known as Aunt Sukie, was born in 1804 in South Truro. Her first husband, Capt. Atkins Rich, was lost at sea in 1828. Her second husband, Ezekiel Atwood, was drowned in the gale of 1841, along with many others from Truro. In 1870, her son Captain Atkins and a grandson were lost at sea. At prayer meetings held at her home, she is known to have said, "The ocean is my cemetery." In 1929, her home was moved to Wellfleet, where it overlooks the harbor. (Photograph courtesy of Susan Hamar.)

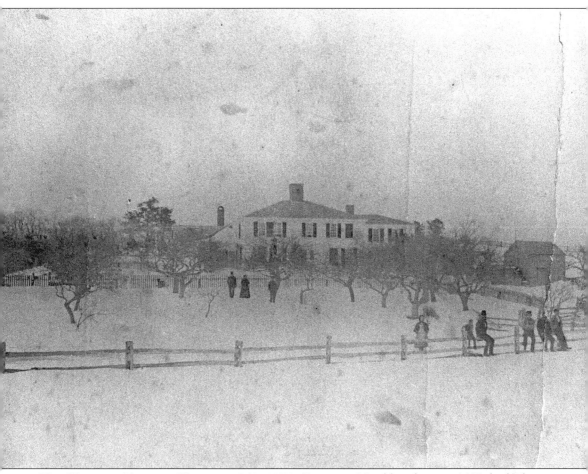

THE HAMBLEN FARM IN WINTER, 1860–1870. Benjamin Hamblen, born in 1692, built the first house on this land, probably around the time of his marriage to Anne Mayo in 1716. Hamblen made his living on long whaling voyages, and it was at the southern tip of South America that he lost his life. A large whale had been killed and brought to the side of the ship. "As the hands were hoisting the blubber into the hold, the runner of the block gave way, and fell with great force, on the head of a man, who stood underneath—Benjamin Hamblen—and instantly killed him." After the earlier house burned in 1796, Hamblen's descendant Cornelius Hamblen II built a large, square hip-roofed house with intricately carved mantels and moldings. By farming, owning boats, and operating salt mills, he supported his wife, Ruth Brown, and their 10 children here on Hamblen Farm Road. (Photograph courtesy of Julian Anthony.)

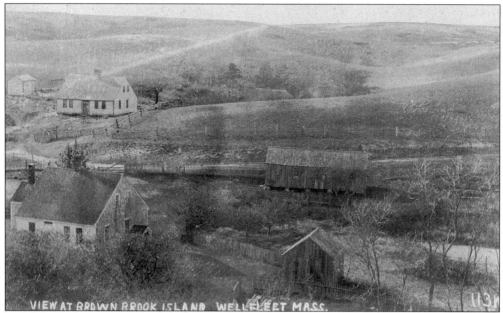

VIEW AT BROWN BROOK ISLAND WELLFLEET MASS.

BOUND BROOK ISLAND AND ITS THRIVING COMMUNITY OF SEAFARING FAMILIES. By the late 1700s, there were saltworks and whale watchtowers here. Until about 1850, Bound Brook Island's Duck Harbor was navigable. The only way on or off was by a bridge to Myrick's Island and another to Griffin's Island. At least 16 homes and a schoolhouse were there until Duck Harbor and the Herring River marshes began to silt in. Few houses now remain; several were moved off the island to other parts of Wellfleet.

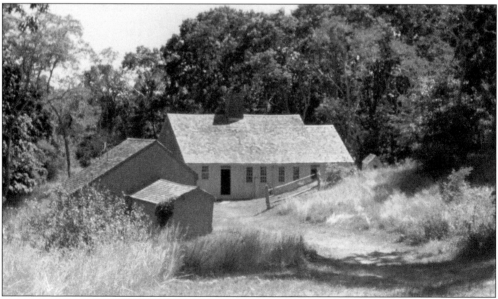

THE ATWOOD-HIGGINS HOUSE ON BOUND BROOK. The Atwood-Higgins House is part of the National Seashore and is maintained by the National Park Service. A great example of the renowned Cape Cod architectural style, it was begun c. 1730 by Thomas Higgins. The house left the Higgins family in 1805 when Thomas Atwood bought it, but the Higgins family later regained ownership.

THE HOPKINS BROTHERS, RICHARD, NEHEMIAH, AND ELISHA. Nehemiah Somes Hopkins began life in 1860 on Bound Brook Island. He became an eye doctor and surgeon just as China was opening to the West, and decided to devote his life to missionary work there. His first medical facilities were set up in makeshift buildings next to a Methodist mission. In 1899, he offered to build an eye hospital in Peking and when it was completed nine years later, he went on to establish the Peking Union Medical College. China bestowed upon him the title of honorary cousin of the emperor. When Japan invaded China in World War II, Hopkins was captured and held in concentration camps for more than two years. He, and the hospital he had founded and named for his deceased brother, John L. Hopkins, survived the war.

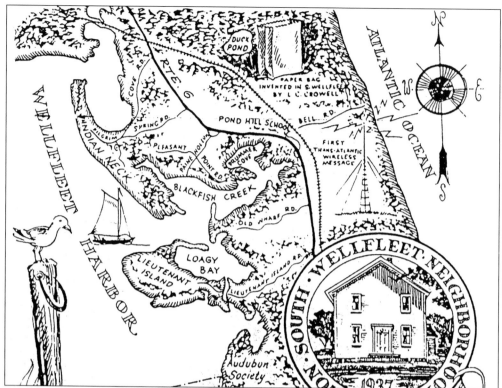

COMMEMORATIVE MAP OF SOUTH WELLFLEET, 1937. In 1833, 42 members of the First Church withdrew to form the Second Congregational Church in South Wellfleet. This map features Indian Neck, Lieutenant Island, L.C. Crowell's invention of the square-bottomed paper bag, and the site of Marconi's first transatlantic wireless message from the United States.

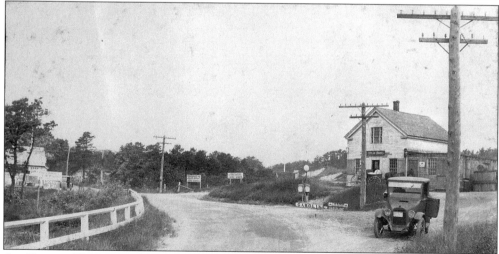

AN UNSEEN HISTORY. The Quiet Crossroads of South Wellfleet, with Isaac Paine's general store, belie the rich history of the village. For a time, beginning in 1819, South Wellfleet became a center for Methodist camp meetings. Enormous crowds camped in tents and wagons and proclaimed, with great religious fervor, their anti-alcohol and tobacco philosophy. South Wellfleet built its own Methodist church in 1834.

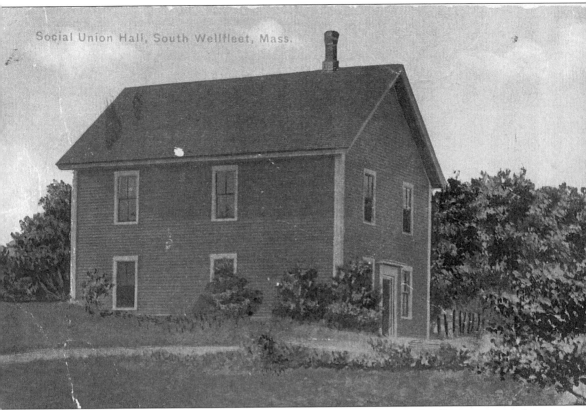

Social Union Hall, South Wellfleet, Mass.

THE POND HILL SCHOOLHOUSE, SOUTH WELLFLEET. By 1859, 12 schoolhouses served the small villages within Wellfleet. The Lewis family built the Pond Hill School in 1857. Fresh Brook Village, also in the southern part of town, built its own school too, in the days before the town formally took over education. These schools helped balance the town's abundance of taverns. In South Wellfleet were Aunt Lydia's Tavern, Reuben Arey's Tavern, and Lydia Taylor's "store." Lydia Taylor, also known as "Aunt Jibboom," served up plenty of "high jinks and strong drinks." Nine years after the Pond Hill School was abandoned in 1880, the Ladies Social Union bought the building for wholesome entertainment, lectures, and a library. In 1937, the South Wellfleet Neighborhood Association was founded here.

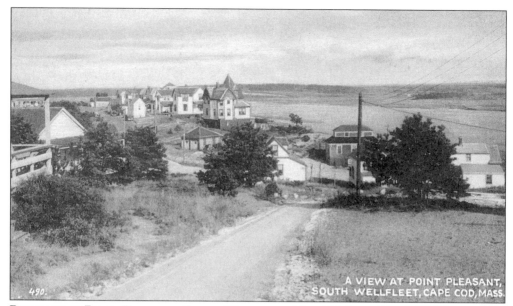

POSTCARD OF POINT PLEASANT, SOUTH WELLFLEET. The tidal flats of South Wellfleet yielded clams, oysters, and scallops; Blackfish Creek provided anchorage and wharves for mackerel and cod boats. The village prospered and established several schools, two churches, a post office, and a railroad station, where men gathered to smoke and swap tales.

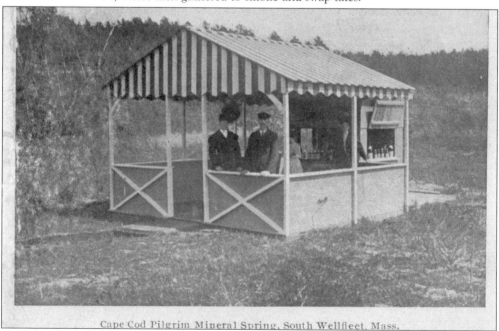

CAPE COD PILGRIM MINERAL SPRING, 1909. For generations, the Atwood family ran this health spring in South Wellfleet, with the claim that "when the Pilgrims landed at Provincetown, and the first settlers located here, it was then highly prized by the Indians, and from that time to the present, has been sought for its purity, and as a remedial agent in stomach and kidney troubles." A sign on the side of the building stated, "Over the hills just under the lea, / Flow sparkling waters pure and sweet / Of that fountain by the sea."

LOU HATCH AT HIS SOUTH WELLFLEET FARM AT THE END OF CEMETERY ROAD, 1938.
Twice a week, Lou Hatch rode his buckboard to Wellfleet center to pick up table scraps to feed his pigs. On a cold winter night, the 18th-century house in which he lived alone burned to the ground and "Hatchie" perished with it.

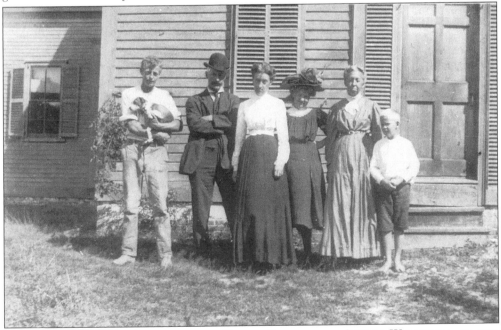

A PORTRAIT OF THE CROWELL AND PIERCE FAMILIES OF SOUTH WELLFLEET AT THE CROWELL HOMESTEAD, C. 1900. Seen here, from left to right, are Sylvanus R. Pierce holding the dog, Luther Francis Crowell, Paulina Evelyn Pierce Crowell, Katherine N. Pierce, Bethiah Pierce, and Asbury C. Pierce. (Photograph courtesy of Phyllis A. Scott.)

THE INVENTOR. By the time Luther Childs Crowell died in South Wellfleet in 1903, he had been ranked one of the most prolific inventors of the 19th century. In 1862, he patented a flying machine, 40 years before that of the Wright Brothers. He flew it in West Dennis, where citizens had already petitioned the court to determine his sanity. Crowell, declared gifted by the local magistrate, flew his plane from the second floor of a barn into a marsh. Crowell married Margaret Atwood and moved to South Wellfleet. His Double Supplement Printing Press made him a fortune and made the efficient printing of prominent New York newspapers possible. Remembered today mostly for the invention of the square-bottom paper bag, Crowell's imaginative flights of inventiveness are recorded in the histories of aviation and printing. (Photograph courtesy of Phyllis A. Scott.)

Four

THE LOST ISLAND OF BILLINGSGATE

The ocean, like an indecisive sculptor, putters around with Cape Cod, chipping off here and slapping on there, to suit its mood of the moment; and the recent disappearance of the island of Billingsgate is one of its most striking changes in the design.
—Jeremiah Digges, Cape Cod Pilot, 1937

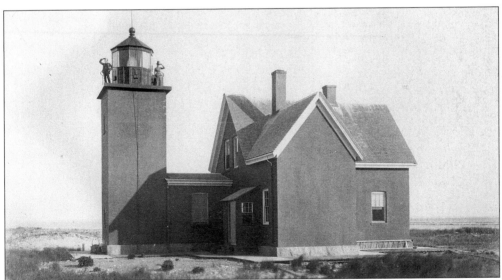

THE BILLINGSGATE LIGHTHOUSE, BUILT IN 1858. It was 100 years from the 1822 building of the first lighthouse on Billingsgate to the hauling away of the last bricks from the ruins in 1922. Generations had lived on the island, built homes, a school, wharves, and made their living from the rich sea. But the sea swallowed Billingsgate, and nothing is left but the legends of its lighthouse keepers and the ghosts, from the first Native Americans to the last Finn to live there.

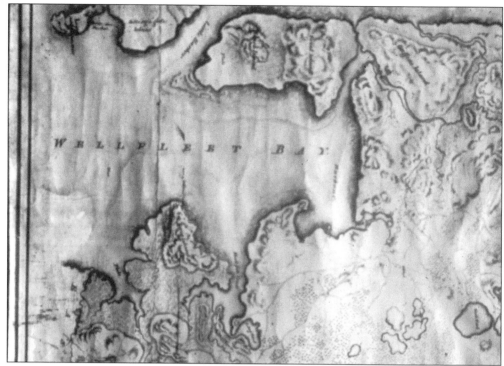

A MAP OF WELLFLEET HARBOR, 1831. The top of this map shows the western end of Wellfleet Harbor, with Billingsgate Island, Great Island, and Griffins Island. In December 1620, as the Pilgrims explored Cape Cod Bay in their shallop, William Bradford spotted Billingsgate Island. He described it as "a tongue of land, being flat, off from the shore, with a sandy point." Mayflower passenger Constance Hopkins and her husband Nicholas Snow were the first-known European owners of the island, possessing it in the 1640s. (N.S.)

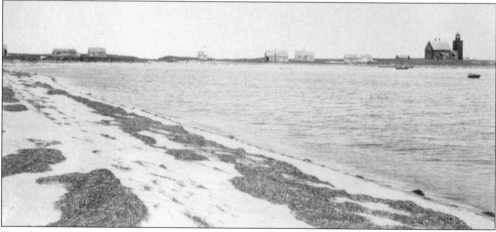

THE LOST VILLAGE ON BILLINGSGATE. In its earliest recorded years, Native Americans fished from the island. In 1822, the first lighthouse was built here, only the third one on Cape Cod, preceded by one in Truro and one in Provincetown. There were nearly 30 homes on Billingsgate Island; however, the families' security was threatened early on. The battered lighthouse was repaired in 1854, but a gale that winter carried away much of it. A new lighthouse was completed away from the eroding shore in 1858.

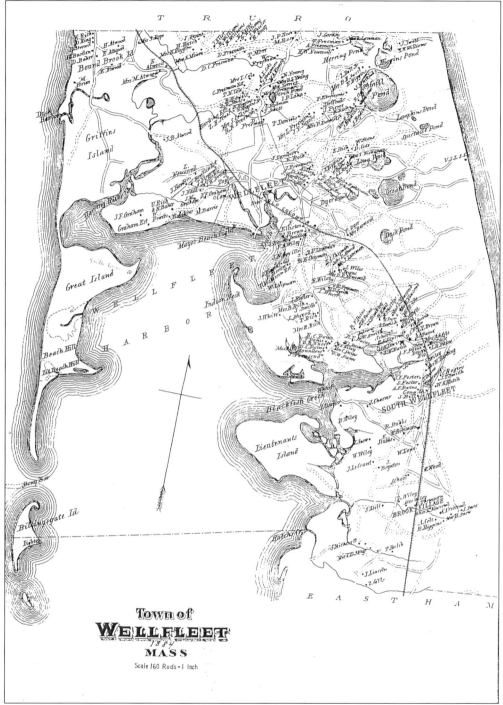

A MAP OF THE TOWN OF WELLFLEET, 1884. Billingsgate Island and its lighthouse marked the southwest perimeter of Wellfleet Harbor. An 1880s keeper's log records "Eighteen whales shot to-day," and "hundreds of seals nearby." In a two-year period, 14 diggers at the island reaped 35 barrels of clams a day.

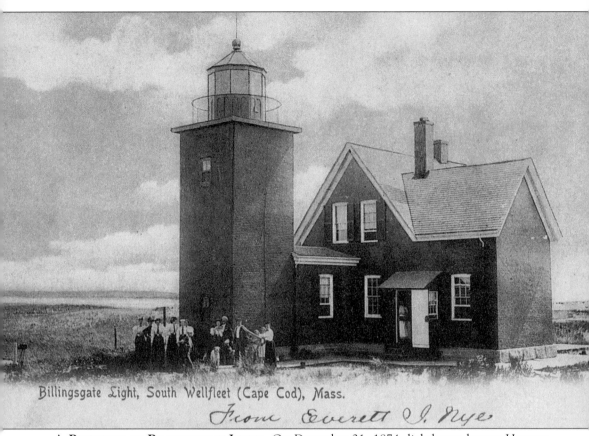

Billingsgate Light, South Wellfleet (Cape Cod), Mass.

From Everett O. I. Nye

A POSTCARD OF BILLINGSGATE LIGHT. On December 21, 1874, lighthouse keeper Herman Dill wrote in his log, "We have had quite a heavy blow and a very high tide, the highest for a number of years. [The sea] broke through at the north end of the island, filling the middle of the island full, running up to the south corner of the foundation on which stands the lighthouse, carrying away the walk which leads to the wharf. I could stand on the south corner and jump into four feet of water." On February 7, 1875, he wrote, "it has been very Cold here for the Last Month and the most ice that I ever see. . . We are almost buried up in it. No salt water to be seen from the Island I have not Seen a Living man for over a month no prospect for the Better. I do get the Blues some times . . . I Can Not Move in either Direction for the ice is 15 feet high in some places." On November 17, 1875, he wrote, "i do not know but the Island will All wash away." His last entry was made on March 26, 1876: "the very worst storm for the winter was Last Night." Herman Dill was found dead, afloat in the lighthouse dory the following day.

THE LAST BILLINGSGATE LIGHTHOUSE KEEPER. This gentleman, seen entertaining Edith Thatcher of South Orleans, could well be the last keeper of the Billingsgate Lighthouse. In 1910, the lighthouse was uninhabitable. As the sea undermined the tower, ropes steadied it and men climbed to remove the lens and beacon. (N.S.)

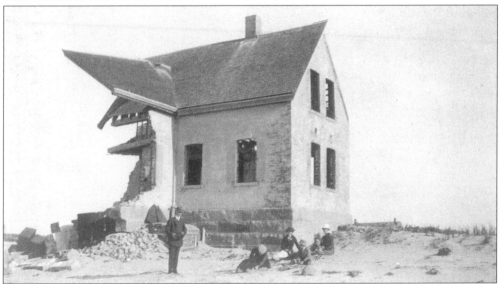

THE BILLINGSGATE LIGHTHOUSE IN RUINS. In 1922, exactly 100 years after the first Billingsgate Lighthouse was built, the last lighthouse was in ruins and the bricks were ferried from the island. Several of the Billingsgate houses and oyster sheds were eventually floated off the remains of the island and became noted landmarks in other parts of Wellfleet. Down from about 50 acres to barely 5, the island was becoming a ghost town. Along with houses that were carried across the bay went tales of mysterious lights and witches.

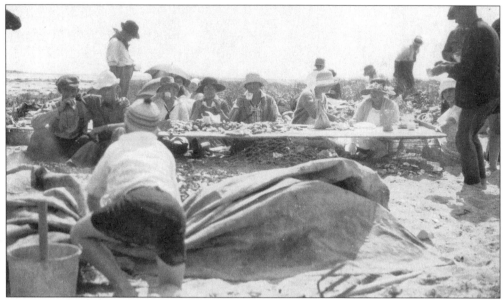

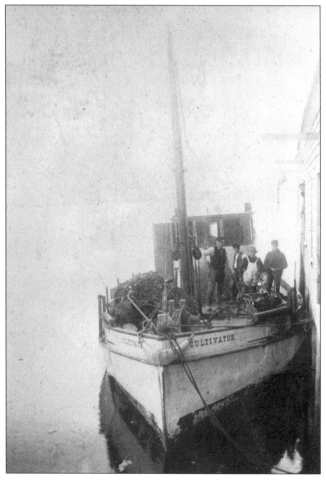

BILLINGSGATE ISLAND, C. 1915. "By invitation of Mr. Walter S. Baker of Concord, N.H., who is summering at the Morning Glory, a very enjoyable clam-bake, at which about thirty people were present, was held at Billingsgate Island. The day was all that could be desired, and all the people smiled in their happiness. Baked clams and green corn, sandwiches, pastry, fruit and lemonade made a sumptuous bill of fare, which healthy appetites soon appropriated and which vanished like dew before the morning sun," reported the *Cape Cod Item and Bee* on August 22, 1899. (N.S.)

CAPT. GUS HOWE'S OYSTER BOAT, THE *CULTIVATOR*. Before World War I, Gus Howe used his oyster boat to take parties out for excursions to Billingsgate. In 1897, Dr. Maurice Richardson, a Boston surgeon, bought part of the island for a summer place and sportsmen's club. (N.S.)

A BILLINGSGATE CLAMBAKE. The *Cultivator* can be seen on the shore after delivering a clambake party to the island. In *I Remember Cape Cod*, E.G. Janes wrote of the Cape Cod Clam Chowder Club, which took the *Cultivator* out to the island with a "great heap of baggage and provender." A clam pit was dug on the beach and lined "with rocks from the dilapidated jetty and the foundation stones of tumble down homes." The meal of baked clams and quahog chowder ended with ice-cold soda, or tonic, and watermelon. "For the younger element, it was time to explore the ruins of the old houses, or to climb the iron framework of Billingsgate Light tower, to hunt for shells across the flats . . . before it was time to pack up the baggage and board the *Cultivator* for the sail home across the sunset-tinted waters of the bay." (N.S.)

EMIL POIKONEN, THE LAST TO LIVE ON BILLINGSGATE ISLAND. Finns were drawn to Wellfleet in the early 1900s for railroad work, cranberry harvesting, and shellfishing. Emil Poikonen, also known as Amos, lived on deserted Billingsgate Island for three or four years before returning to Finland with enough money to buy a sawmill and marry. The Federated Bird Clubs of New England took over the island for a bird refuge in 1928. However, by 1935, even the mud flats of Billingsgate were gone during high tides. All that is left of the mysterious island is a crescent of sand at low tide and a mark on mariners' maps warning of the Billingsgate Shoal.

Five

LEGENDS OF PIRATES,
WITCHES, AND VOICES
IN THE WILD HILLS

Goodie Hallett's familiars, a black cat and a black goat, were said to ride porpoises'
backs, following in the wake of ships. Seamen of Wellfleet . . . exclaimed:
"Thar be Goodie Hallett's familiar waitin' to pick up souls."
—Elizabeth Reynard, from The Narrow Land, *1934.*

AN ILLUSTRATION OF SAM BELLAMY OF THE PIRATE SHIP WHYDAH. The wreck of the *Whydah* in 1717 was the most famous of all Cape Cod shipwrecks. More than 140 pirates died in a gale off Wellfleet. Legend says Bellamy had sailed his gold-laden pirate ship to Wellfleet to return to his lover, Maria Hallett, whom time has since turned into a soul-stealing witch. The true story, from Sam Bellamy's piracy in the West Indies to the wreck of the *Whydah* and the hanging of six of his men, is told in court records in Boston.

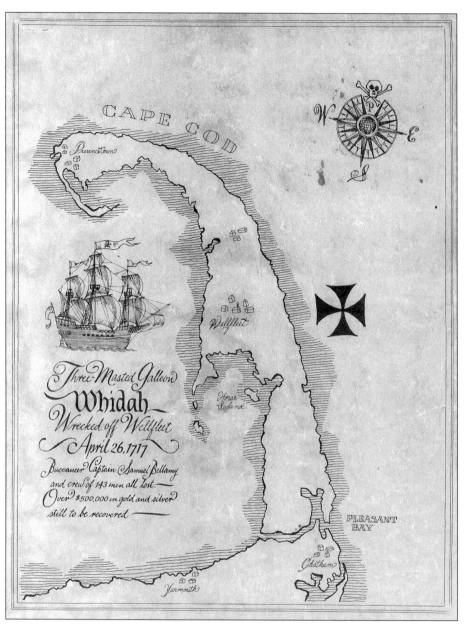

On the map (within the illustration):

C A P E C O D

Provincetown

Three-Masted Galleon
Whidah
Wrecked off Wellfleet
April 26, 1717
Buccaneer Captain Samuel Bellamy
and crew of 143 men all lost —
Over $500,000 in gold and silver
still to be recovered —

Wellfleet

Horse Island

PLEASANT BAY

Chatham

Yarmouth

W · N · E · S

THE MAP OF A PIRATE'S SHIPWRECK. A black cross marks the wreck of the *Whydah* on this fanciful modern map. The legend is told of "Black Sam Bellamy" of the West Country, England, who sailed to the Wellfleet area on his way to a life of piracy in the West Indies. While allegedly staying at Higgins's Tavern, he heard the voice of a girl under a tree. Maria Hallett, 15 years old, with hair that "glistened like corn-silk at suncoming; her eyes the colour of hyacinth, like the deeps of Gull Pond," enchanted him. Black Bellamy "made masterful love, sailorman love that remembers how a following wind falls short and makes way while it blows." Elizabeth Reynard writes that "Love was settled between them . . . under the apple-tree by the Burying Acre, and Sam sailed away with a promise to Maria that when he returned he would wed her . . . and in a sloop, laden with treasure, carry her back to the Spanish Indies." (From Elizabeth Reynard, *The Narrow Land*, 1934.)

PIRATE SHIPS OF BELLAMY'S DAY, FROM JOHNSON'S *GENERAL HISTORY OF THE PIRATES*, LONDON, 1725. The first authentic record of Sam Bellamy is in the West Indies where he, Capt. Benjamin Hornygold, and Capt. Louis Lebous plundered ships and forced captives into piracy. In February 1717, Bellamy intercepted the *Whydah*, a London-built galley, sailing through the Windward Passage between Cuba and Puerto Rico. The *Whydah* had taken slaves on the coast of Guinea and traded them for a rich cargo of ivory, gold dust, sugar, and indigo. Bellamy took the ship, which had 18 guns and a crew of 50.

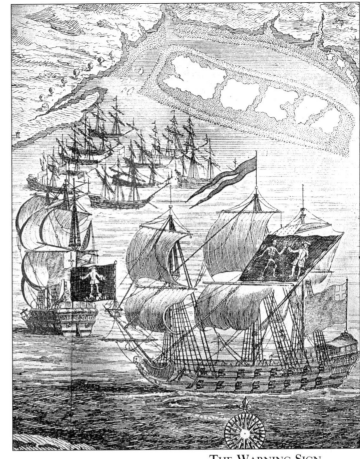

THE WARNING SIGN. Bellamy flew a large black flag "with a Deaths Head and Bones a-cross" as he plundered his way through the Bahamas and along the coast of Virginia, taking English, Scottish, and French ships along the way. The last two ships captured—the *Mary Anne* of Dublin with a cargo of Madeira wine, and a sloop from Virginia—were taken not far from Nantucket. The *Whydah* and the captured ships made their way along the treacherous back shore of the Cape. The combination of Madeira and a violent storm led to the wreck of the pirate fleet.

Inſtructions to the LIVING, from the Condition of the DEAD.

A Brief Relation of REMARKA-BLES in the Shipwreck of a-bove One Hundred

Pirates,

Who were Caſt away in the Ship *Whido*, on the Coaſt of *New-England*, *April* 26. 1717.
And in the Death of Six, who af-ter a Fair Trial at *Boſton*, were Convicted & Condemned, *Octob.* 22. And Executed, *Novemb.* 15. 1717. With ſome Account of the Diſcourſe had with them on the way to their Execution.

And a S E R M O N Preached on their Occaſion.

Boſton, Printed by *John Allen*, for *Nicholas Boone*, at the Sign of the *Bible* in *Cornhill*. 1717.

THE SPANISH DOUBLOON FOUND ON THE BEACH AFTER THE WRECK OF THE WHYDAH. On April 26, 1717, the *Whydah* wrecked about two miles south of Cahoon's Hollow. Only two of the ship's 146 men reached the shore alive: Thomas Davis, a young Welsh shipwright, and John Julian, a Native American born on the Cape. The *Whydah* may have been betrayed by the captain of the *Mary Anne* and was drawn too close to the shore. Within 15 minutes of striking, the mainmast crashed overboard and by the next morning, the tangled mass of wreckage and bodies was strewn along Wellfleet's back shore.

"SHIPWRECK OF ABOVE ONE HUNDRED PIRATES . . ." Outraged by the physical and moral threat of pirates on Cape Cod shores, Cotton Mather published a sermon in which he claimed that, as it appeared to the depraved men that the *Whydah* was breaking up, "the pirates murdered their prisoners on board lest they should escape and appear as witnesses. Wounds were afterwards found on their dead bodies washed up by the sea." (Photograph courtesy of the Massachusetts Historical Society, Boston.)

THE ACCOUNT OF THE TRIAL OF SAM BELLAMY'S PIRATES, PUBLISHED IN BOSTON, 1718. Nine pirates were captured, two from the *Whydah* and seven from the *Mary Anne*, and held in the Barnstable Jail. They were taken on horseback to the stone jail in Boston and placed in irons on May 4. Bellamy himself had died in the shipwreck of the *Whydah*. At the October 18, 1717 trial in Admiralty Court, six of the surviving men were condemned to die. Thomas Davis, the Welsh shipwright, was cleared, and Native American John Julian disappeared and may have been sold into slavery. The condemned pirates—originally from Jamaica, Holland, France, and New York—were sentenced to be hanged on Friday, November 15, 1717, "at Charlestown Ferry within the flux and reflux of the Sea." (Photograph courtesy of the Massachusetts Historical Society, Boston.)

THE

TRIALS

Of Eight Perſons.

Indited for Piracy &c.

Of whom Two were acquitted, and the reſt found Guilty.

At a Juſticiary Court of Admiralty Aſſembled and Held in Boſton within His Majeſty's Province of the Maſſachuſetts-Bay in New-England, on the 18th of October 1717. and by ſeveral Adjournments continued to the 30th. Purſuant to His Majeſty's Commiſſion and Inſtructions, founded on the Act of Parliament Made in the 11th. & 12th of KING William IIId. Intituled, *An Act for the more effectual Suppreſſion of Piracy.*

With an APPENDIX,

Containing the Subſtance of their Confeſſions given before His Excellency the Governour, when they were firſt brought to *Boſton,* and committed to Goal.

Boſton :

Printed by B. Green, for John Edwards, and Sold at his Shop in King's Street. 1718.

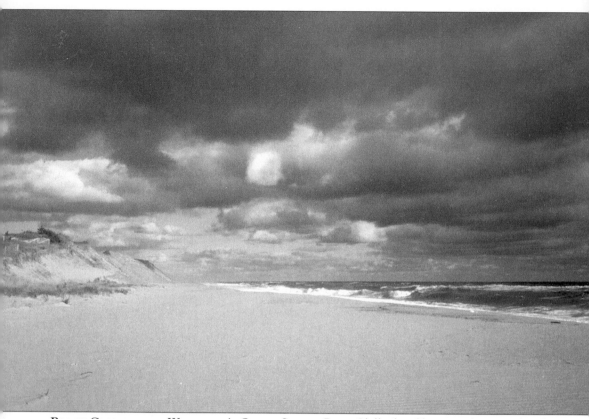

BLACK CLOUDS OVER WELLFLEET'S OUTER SHORE. Barry Clifford and his crew discovered and salvaged the *Whydah* off Cahoon's Hollow in the 1980s. Gold and silver, cannons, the ship's bell, and personal belongings of the pirates are on exhibit in the Whydah Museum in Provincetown. Maria Hallett's fate was to be portrayed first as Bellamy's lover and then as the Sea Witch of Billingsgate. It is said that at age 15, she was found lying in a barn with the dead baby of Sam Bellamy in her arms. While in jail, she made a pact with the Devil: her soul in exchange for the vengeful drowning of Bellamy on the *Whydah*. For nearly 100 years, she preyed on mariners, accompanied by her black cat and a goat with a glass eye. She sometimes lived in the belly of a whale, where she created shrieking tempests and played dice with the Devil for the souls of sailors. (Photograph by Daniel Lombardo.)

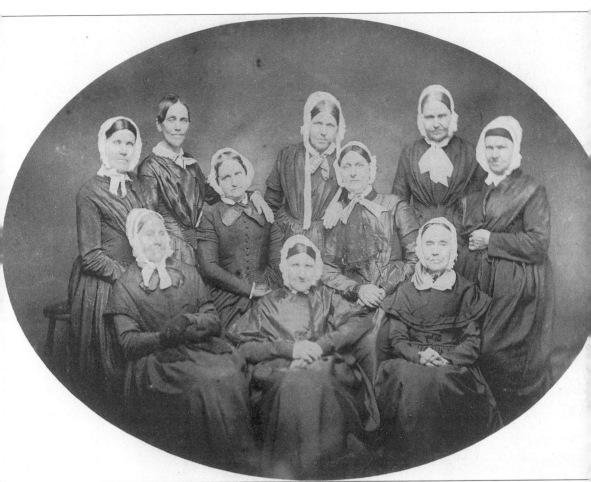

THE TEN GROSS SISTERS, SEPTEMBER 28, 1851. Of the 14 children of Thomas and Abigail Gross, 10 daughters became known as the angelic singers of the Wellfleet Methodist Church. Through their uncle John Young, who was rescued in Hawaii by the island king's daughter, whom he married, the sisters were related to the Hawaiian royal family. (See the *Zion's Herald*, September 25, 1918.) Cynthia Gross, seen at the far left, entered local folklore as the Cape's most famous midwife, with powers to heal people and all creatures. It is said that on misty nights she sat in a rocker and knit in the Burying Acre between the village and the Gross home near Gull Pond. She sang hymns to the dead, who murmured in response, and talked calmly to a horned, blue sulfur devil when he appeared from a crumbling tomb.

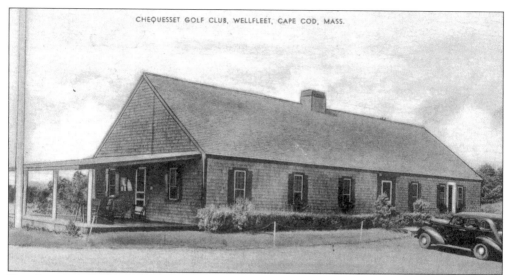

THE CHEQUESSETT GOLF CLUB. When this country club opened in 1931, founder David Baker told the *New York Times* of his ancestor Joseph hearing "angelic voices" in the heavens singing "So pilgrims on the scorching sand, Beneath a burning sky, Long for a cooling stream at hand, And they must drink or die." His grandmother had gathered apples there once and heard the singing, followed by the name of her sick neighbor and the words "She's dying!" She ran back over the wild hills to find her neighbor was indeed at the edge of death.

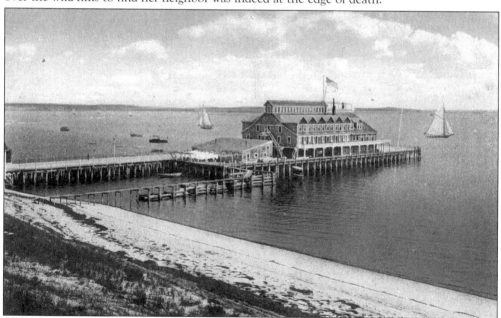

A FABLED INN. The Chequessett Inn was reputed to have been a place where rum smugglers operated during Prohibition; it is said that one prominent gangster permanently reserved Room 43. Ned Lombard today tells of watching in disbelief as smugglers unloaded liquor on a foggy night at Indian Neck. Many old tales of Wellfleet were told at the Chequessett Inn before the sea took it in 1934. There is the tale of Capt. Jedidy Cole tricking the Devil into climbing the Wellfleet Oak, and tales of Lumpkin's Hole, where a lantern from Captain Lumpkin's shipwreck was seen over the lost island of Billingsgate.

Six

SHIPWRECKS

"The sea is mother-death and she is a mighty female,
the one who wins, the one who sucks us all up."
—Anne Sexton, from The Poets Story, 1971

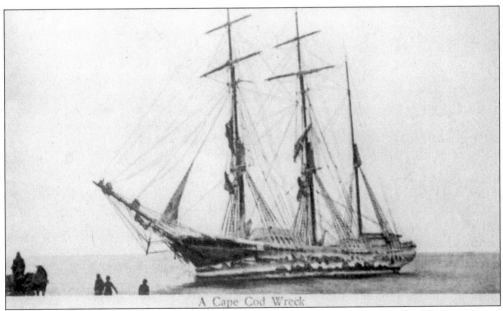

A Cape Cod Wreck

A CAPE WRECK. Isaac Small, stationed at Highland Light in 1861, wrote "the whitened bones of hundreds of dead sailors lie buried in the drifting sands of this storm beaten coast." Of 3,000 Cape wrecks, these are a few lost off Wellfleet: the *Whydah*, 1717; the *Cactus*, 1847; the *Cambria*, 1849; the *Franklin*, 1849; the *St. Cloud*, 1863; the *White Squall*, 1868; the *Kilhorn*, 1874; the *Florida*, 1890; the *Gray Eagle*, 1890; the *Jason*, 1893; the *Messenger*, 1894; the *Fearing*, 1896; the *Welcome*, 1896; the *Heisler*, 1897; the *Empire State*, 1899; the *Holden*, 1899; the *Smuggler*, 1899; the *Black Bird*, 1900; the *Campbell*, stranded in 1912; the *Mead*, 1913; the *Castagna*, 1914; the *Hickey*, 1927; and the *Paulmino*, 1959.

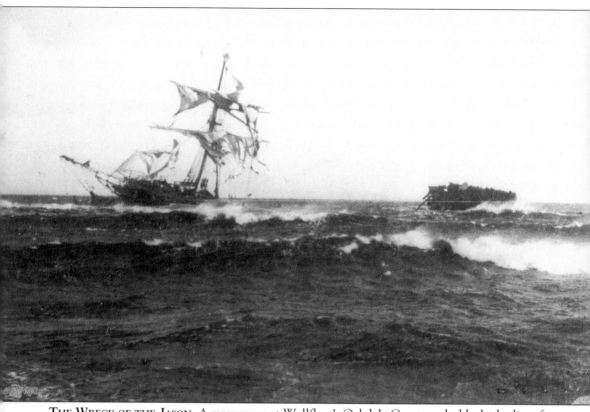

THE WRECK OF THE JASON. A mass grave at Wellfleet's Oakdale Cemetery holds the bodies of the men of the *Jason*, lost on December 5, 1893, near the Pamet River Life Saving Station in Truro. Beginning its voyage in Scotland, the *Jason* carried coal from South Wales to Calcutta, where it picked up a cargo of Jute and headed for Boston. The trip seemed doomed, for the *Jason* had collided with a steamer off Wales and lost sails and spars in a storm off India. Capt. George McMillan attempted to round Cape Cod but was met by a northeast gale. The ship struck the outer bar and broke up, and the loss of life was nearly total. Lifesavers from the Truro and Wellfleet stations were met by bodies and bales of jute washing ashore. Only Englishman Samuel J. Evans survived to tell his tale: "I gained the mizzen rigging with the others, but was quickly knocked off by the sea . . . Battered and bruised I was hurled toward the shore . . . Washed heels over head in the terrible breakers . . . I was pounded dreadfully, but I managed to crawl up the beach . . ."

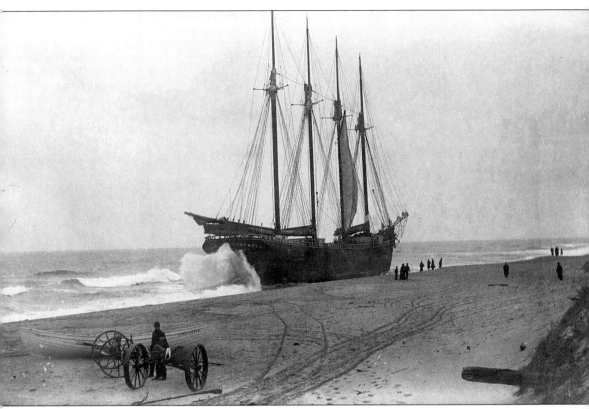

THE TWICE UNLUCKY CAMPBELL, 1895. The schooner *Charles A. Campbell* was stranded in thick fog for the first time on March 14, 1895, at 4:00 a.m. near the Pamet River Station. The same ship ran aground again on October 7, 1912, in South Wellfleet, while attempting to carry coal from Norfolk, Virginia, to Boston. (N.S.)

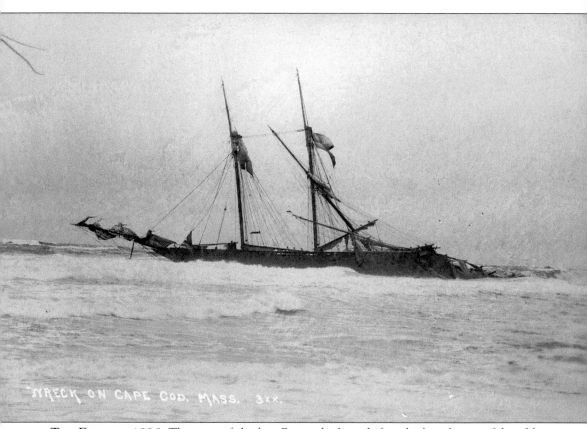

WRECK ON CAPE COD. MASS. 3xx.

THE *FEARING*, 1896. The crew of the lost *Fearing* had much for which to be grateful, unlike the sad story of the earlier wreck of the *Franklin*, of which no photograph exists. In 1849, Capt. Elisha H. Baker wrote to his sister: "The ship *Franklin* of Boston came ashore on the Cape [at Newcomb's Hollow] about four o'clock in the morning of March 1st, from London, with 32 souls on board. The captain and mate with some of the crew and one girl, 11 in number, attempted to land in the long boat and were upset and all drowned. That left 21 on the wreck. The ship then broke in two and the survivors took the bow, the sea at times breaking over them. There were three women among those on the wreck . . . one had her husband with her and a nursing babe . . . He and the child were among those that were saved . . . I hear that the poor unfortunate man's wife has been found with her wedding ring on her finger . . ." In a tragic twist, the owners of the wreck were indicted and accused of purposely wrecking the ship to collect the insurance.

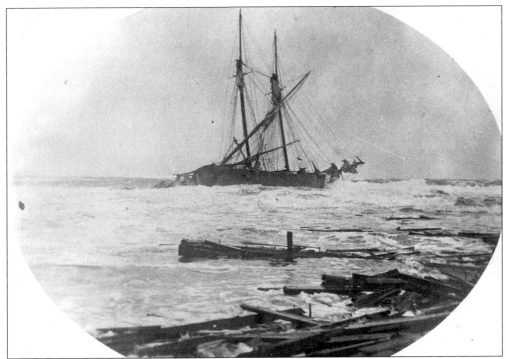

THE WRECK OF THE *DANIEL B. FEARING*, 1896. On May 6, 1896, the Newport schooner *Fearing* hit a northeaster a mile north of Cahoon's Hollow. Bound from Philadelphia to Boston, the ship was pounded to pieces by the surf. The Cahoon's Hollow Life Saving Station successfully rescued the entire crew, having been delayed only by the cook who, at the last minute, scrambled back to the galley to save his cat.

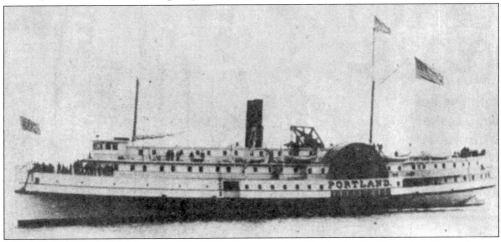

LOST IN A GALE. On November 26, 1898, the steamship *Portland* sailed from its pier in Boston on a regular trip to Portland, Maine. Before midnight of the following day, the ship's broken timbers, cabin fittings, and dead bodies lined the outer shores of Cape Cod, from Highland Light to Chatham. "Not a person of her 175 passengers and crew survived . . ." The *Cape Cod Item and Bee* reported that "The body washed ashore at Cahoon's Hollow on Monday of last week, identified as that of George Graham, colored porter of steamer *Portland*, was sent to Boston on last Saturday by undertaker O.H. Linnell."

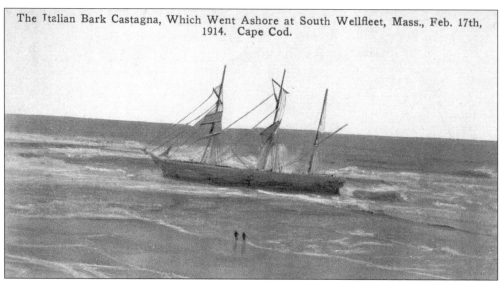

The Italian Bark Castagna, Which Went Ashore at South Wellfleet, Mass., Feb. 17th, 1914. Cape Cod.

THE WRECK OF THE CASTAGNA. In 1914, the *Castagna* left Italy for Massachusetts, by way of South America, little knowing that four of her men would end their lives frozen to the rigging off Wellfleet. The ship had picked up guano and cow horns in Uruguay and had headed north where on February 17, they met bitter wind and waves and came aground two miles south of Cahoon's Hollow. The Coast Guard shot its rope over the ice-covered vessel three times, but the men in the spars seemed to ignore it. A lifeboat was sent out, but only eight men were saved. The captain and three sailors had to be left where they were, frozen to death high above the deck in the ship's rigging.

A FIVE-FRANC NOTE FOUND ON THE BODY OF A SAILOR FROM THE CASTAGNA. The day after the wreck, three frozen bodies were taken from the rigging. This note was in the pocket of one. The ship's captain had been with the three, but his body had washed overboard and was found a year later at Nauset Harbor. Undertaker O.H. Linnel saw to the burial in Wellfleet's Catholic cemetery of Mario Parone, age 19; Satiroff Velio, age 28; and Paolo Ballesirino, age 60.

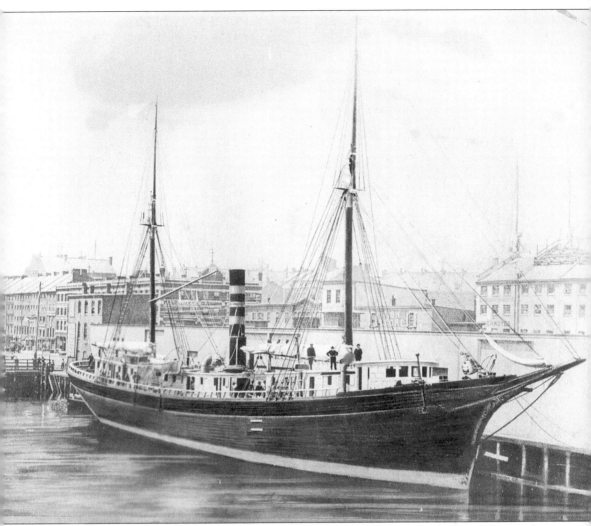

THE STEAMER *L.D. BAKER*, BURNED AT SEA IN 1889. Wellfleet's Lorenzo Dow Baker made his fortune from fruit plantations in Jamaica and Central America. At midnight on July 14, 1889, Capt. Warren Willey of Wellfleet reported that an oilcan had spilled, setting the ship afire off Cape Hatteras. Elizabeth Sime, the only woman on board, recalled clinging to a life raft with 13 others: "It seemed as if torture was in store for us, in the form of exposure, starvation and exhaustion, for we were without food and water . . . We were nearly 300 miles from land, with only three oars . . . and our end seemed near." But the whaling schooner *Franklin* of New Bedford spotted the burning ship. Five men were plucked from the Baker's broken masts. Though they thought no one else had survived, the lifeboat was spotted and all aboard it, including Elizabeth Sime, were rescued.

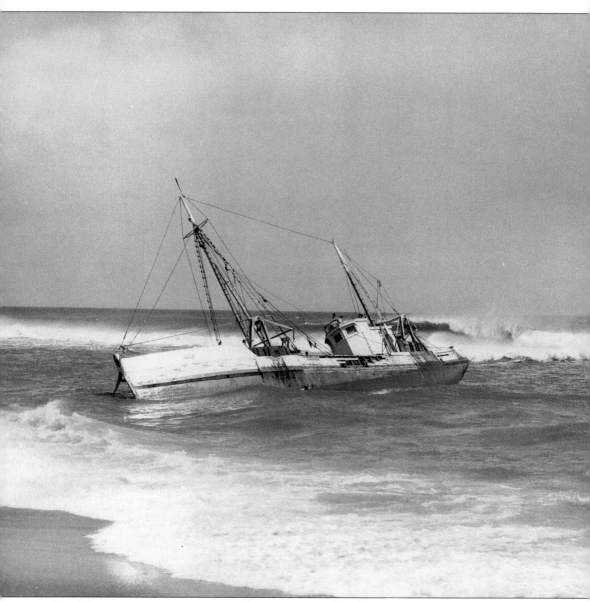

THE WRECK OF THE *PAULMINO*. Modern Coast Guard technology couldn't save the *Paulmino*, which became lost in heavy seas and thick fog on April 3, 1959. This Boston trawler was coming in from the fishing grounds with 30,000 pounds of Haddock when it hit the outer bar of Wellfleet at 1:00 a.m. The crew of seven men waited in vain in the pilothouse for five hours, but the Coast Guard could not locate the ship. Capt. Angelo Marino instructed the men to draw on their life preservers and swim for the beach. Only four of the crew made it to shore alive. Marino was among those who died in the attempt. The wreck was photographed by William P. Quinn. (N.S.)

Seven

THE GREAT BEACH

"One of the most attractive points for visitors is in the northeast part of Wellfleet . . . It best combines the country and the sea-side . . . you have only to climb a hill to find yourself on [the ocean's] brink. It is but a step from the glassy surface of the Herring Ponds to the big Atlantic Pond where the waves never cease to break."
—Henry Thoreau, Cape Cod, 1865.

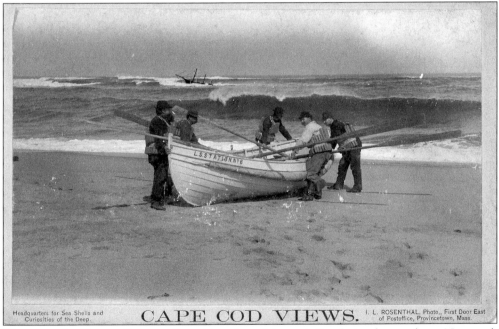

WELLFLEET'S GREAT BEACH. Stretching from Marconi Beach in the south to Newcomb Hollow in the north, Wellfleet's Great Beach is as wild and dramatic today as it was when lifesaving stations sent their boats out to uncountable shipwrecks. American writer Henry Thoreau described the bare-armed, clenched fist of the Cape as "boxing with northeast storms . . . and heaving up her Atlantic adversary from the lap of the earth." (N.S.)

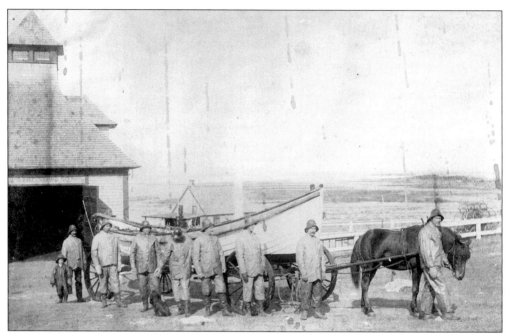

A LIFESAVING CREW IN FOUL-WEATHER GEAR. "Myriads of shoals lie along the coast, and unnumbered vessels have met their doom along its shores, which rightly bear the name 'Ocean Graveyard' . . . while unmarked graves in the burial-places in the villages mutely relate the sad tale of the sacrifice of human life. Scenes of awful terror and heroic rescuers have taken place at the time of shipwreck . . . and the life savers have given up their lives in devotion to their duty." J.W. Dalton, *The Life Savers of Cape Cod*, Sandwich, 1902. (N.S.)

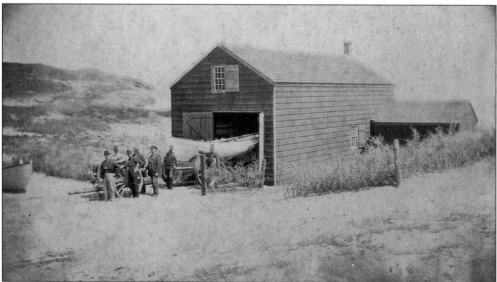

EARLY WELLFLEET HUMANE SOCIETY LIFESAVERS. In 1786, the Massachusetts Humane Society started the country's first lifesaving service, staffed by volunteers. Congress did not appropriate money for lifesaving until 1847 and even then, the crews' training and equipment were poor. A startling Revenue Marine Service report in 1871 found little discipline among crews, stations in ruins, funds wasted, and thefts of critical equipment.

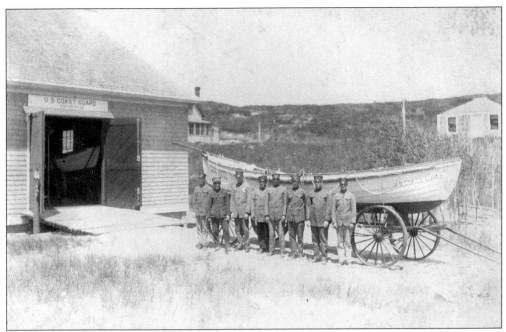

THE U.S. LIFE SAVING SERVICE, CREATED IN 1872. Nine professionally staffed stations were built along Cape Cod, including this one at Cahoon's Hollow. Crews took up residence on August 1 each year for the ten-month "season." Men rotated housekeeping and cooking duties, and each was allowed one day in seven to visit home, between sunrise and sunset. A keeper was appointed to man each station year-round.

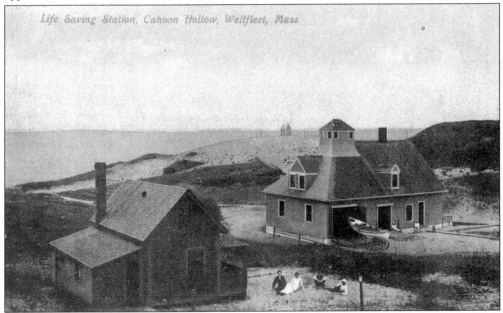

THE NEW STATION. After a fire destroyed the Cahoon's Hollow Station in February 1893, a new building was erected and photographed for this postcard. The Cahoon's Hollow Life Saving Station still stands and ghosts of old lifesavers mingle today with the crowds who dance in a nightclub where once shipwrecked sailors were kept warm.

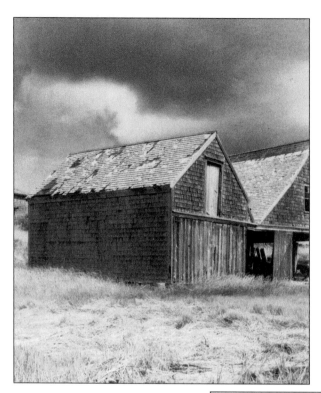

THE HALFWAY HOUSES AT SOUTH WELLFLEET. Beaches were patrolled all night long, and during the day in thick weather. Two surf men were on duty; they set out from the station in opposite directions, heading toward one of the halfway houses. There, they got warm and met the surf man from the adjoining station. They exchanged identification checks as proof that they had reached the halfway house and then return to the main station.

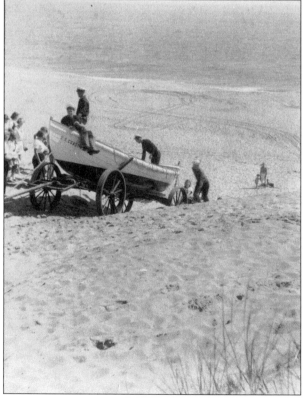

A SURFBOAT DRAWN UP ON WELLFLEET'S OUTER BEACH. The Cahoon's Hollow Station was supplied with two surfboats equipped with oars, life preservers, a compass, a drag, boat hooks, a hatchet, and a heaving line; boat carriages; two sets of breeches-buoy apparatuses with cannons; signal rockets and flags; medicine chests; patrol lanterns; a thermometer; and a barometer.

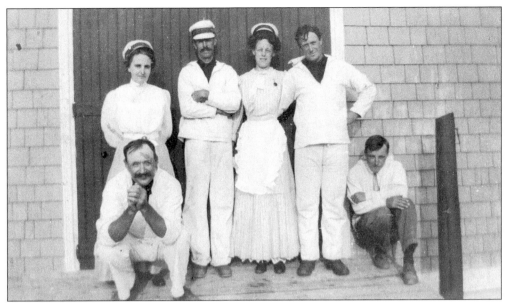

A LIFE OF SERVICE. Capt. Daniel Cole served at the Cahoon's Hollow Station from 1872 to 1905 and was keeper of the station for more than 25 years. Pictured here are members of the Cahoon's Hollow crew and their wives, from left to right, Ed Lombard and his wife, Mr. Ennis, Mrs. Cook, Al Cook, and Asa Lombard. (N.S.)

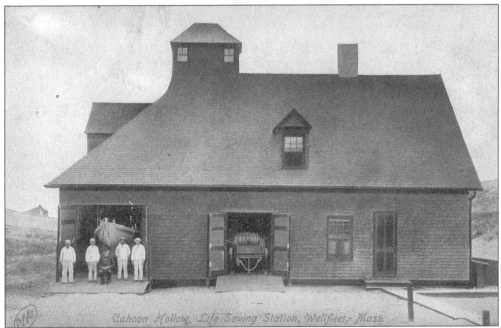

Cahoon Hollow, Life Saving Station, Wellfleet, Mass.

SAFER TIMES. The seas became safer when steel ships replaced sailing ships and when ship-to-shore radio contact was established. The building of the Cape Cod Canal in 1914 made the treacherous journey past Wellfleet's Great Beach unnecessary for most ships. In 1915, the U.S. Coast Guard took over the lifesaving service and discontinued many of the old stations.

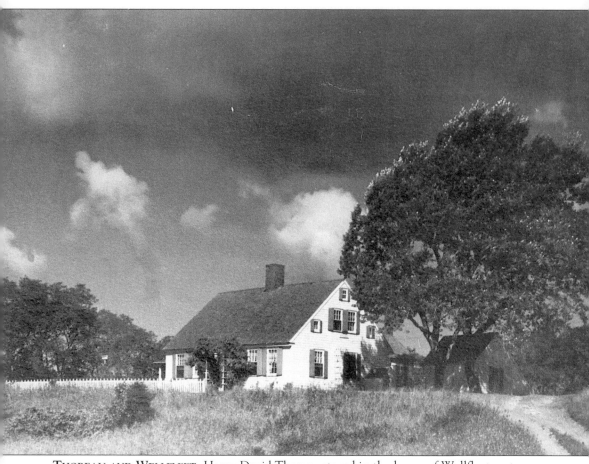

THOREAU AND WELLFLEET. Henry David Thoreau stayed in the house of Wellfleet oysterman John Young Newcomb at Williams Pond in 1849. No one has written about Wellfleet and the Cape with as much affection and depth as Thoreau did. In 1849, he and his friend Channing reached Orleans by stagecoach and walked to Provincetown, by way of Eastham, Wellfleet, and the Highland Light. In 1850, Thoreau took a Boston steamer to Provincetown and walked through Wellfleet and as far south as Chatham before returning to Provincetown for the steamer. Thoreau returned with Channing in 1855 and made a last solo trek in 1857, when he walked from Sandwich, through Harwich, and north through Wellfleet to Provincetown. (Photograph by F.C. Hicks.)

A THOREAU MANUSCRIPT DESCRIBING WELLFLEET OYSTERS, OWNED BY THE WELLFLEET HISTORICAL SOCIETY. "[Oysters were annually] brought from the South and planted in the harbor of Wellfleet, till they attained 'the proper relish of Billingsgate'; but now they are brought from the South commonly full-grown, and laid down near their markets, at Boston and elsewhere, where the water, being a mixture of salt and fresh, suits them better. The business is still good and is improving. The old man said that the oysters were liable to freeze in the winter if planted too high; but if it were [not] so cold as to strain their 'eyes' they were not injured. They keep them in cellars all winter. 'Without anything to eat or drink?' I asked; 'without anything to eat or drink,' he answered. 'Can an oyster move?' I inquired. 'Just as much as your shoe,' he replied. But when I caught him saying that they 'bedded themselves down in the sand flat side up, round side down,' I told him that my shoe could not do that without the aid of my foot in it . . ."

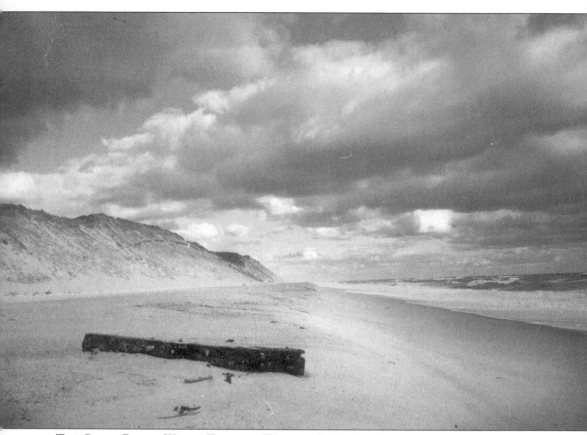

THE GREAT BEACH WHERE THOREAU WALKED, PHOTOGRAPHED TODAY WITH DRIFTWOOD FROM A 19TH-CENTURY SHIPWRECK. Thoreau's famous description of the Wellfleet oysterman and his family included this breakfast scene: ". . . the old man resumed his stories . . . with his back to the chimney, and ejecting his tobacco-juice right and left into the fire behind him, without regard to the various dishes which were there preparing. At breakfast we had eels, buttermilk cake, cold bread, green beans, doughnuts, and tea. The old man talked a steady stream; and when his wife told him he had better eat his breakfast, he said: 'Don't hurry me; I have lived too long to be hurried.' I ate of the apple-sauce and the doughnuts, which I thought had sustained the least detriment from the old man's shots (of tobacco juice), but my companion refused the apple-sauce, and ate of the hot cake and green beans, which had appeared to him to occupy the safest part of the hearth. But on comparing notes afterward, I told him that the buttermilk cake was particularly exposed . . . and therefore I avoided it; but he declared that . . . he witnessed that the apple-sauce was seriously injured, and had therefore declined that." (Photograph by Daniel Lombardo.)

Eight

THE RAILROAD

"All Aboard for Wellfleet!! We are pleased to announce that the evening train Wednesday will be run through to Wellfleet, thus verifying the promise heretofore made the people of that town that they should come to their homes for their Thanksgiving Dinner in 1870 by rail!"
—Provincetown Advocate, *November 23, 1870*

THE ARRIVAL OF THE RAILROAD. This locomotive emerging from the old Holbrook Avenue stone bridge symbolizes a dramatic turning point in Wellfleet's history. Prior to 1870, Wellfleet fishermen sent their catches to Boston by the Provincetown packet ships. By land, passengers began their journeys with stagecoach driver Sam Knowles. His leather-upholstered, yellow and red coach carried nine passengers inside and six to eight on top. Wellfleet celebrated with great style when the railroad came and changed a town wedded to the sea to one with an eye to markets and tourists from inland.

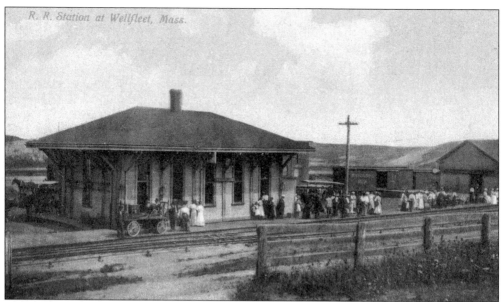

R. R. Station at Wellfleet, Mass.

THE WELLFLEET RAILROAD STATION, OFF COMMERCIAL STREET, OPPOSITE RAILROAD AVENUE. "We need to open a way by railroad to let in the outside world and let ourselves out, that the former may see what can be done here, and ourselves what is being done elsewhere. [It will] allow a little better circulation of people and ideas . . . Every one will welcome the day when our entire dependence will not be placed on the fisheries, the instability of which we do frequently experience," —*Provincetown Advocate*, November 23, 1870

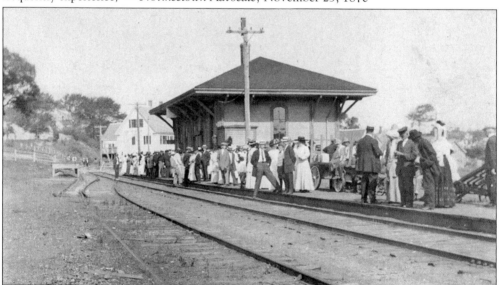

AN ANXIOUS WAIT. Both Wellfleet and Provincetown waited breathlessly as the railroad extended from Boston to Sandwich and to Orleans. The Wellfleet station was officially opened on December 28, 1870: "Wednesday was a glad day for Wellfleet. Long before 12 o'clock the crowds of citizens that thronged the streets, betokened that something unusual was expected. And sure enough, something did occur that never happened before—for soon after that hour the first train of passenger cars arrived at the station in this town!" —*Provincetown Advocate*, January 4, 1871

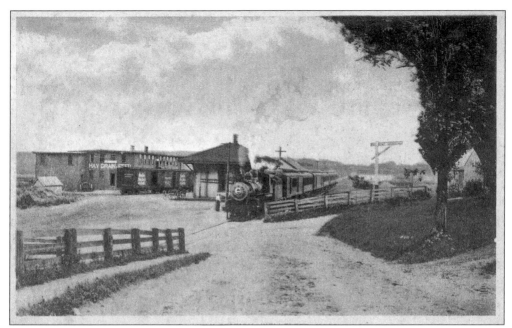

THE COMMENCEMENT OF CELEBRATION. The "general rejoicing" when the Cape Cod Railroad reached Wellfleet began with George T. Wyer marching the Ellsworth Band to the Methodist church on Main Street. The *Providence Advocate* reported that "The dinner [for 400] was excellent, the very best we ever sat down to at so large a gathering . . . At the conclusion of the knife and fork exercises, Dr. T.N. Stone called the meeting to order, and in one of those happy speeches for which he is so renowned, introduced the intellectual part of the festival." The only negative note came from Provincetown, whose officials were miffed at not being invited.

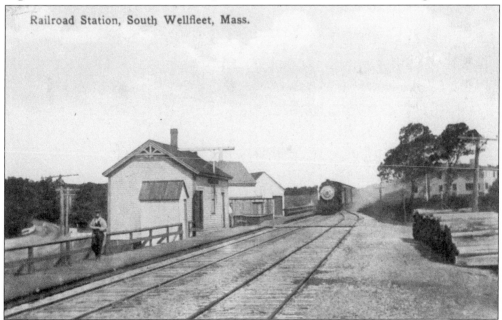

THE RAILROAD EXPANDS. South Wellfleet had its own railroad station as well, as seen in this turn-of-the-century postcard.

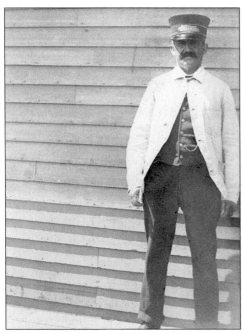

SOUTH WELLFLEET RAILROAD CONDUCTOR ARTHUR NEWCOMB, BORN IN 1856 AND PHOTOGRAPHED IN 1908. As conductor, he had an orchestral variety of signals: a lantern raised and lowered vertically was a signal for starting, swung at right angles meant "stop," swung in a circle, "back the train." A red flag waved upon the track meant "danger," as did "other signals given with energy." A rapid succession of short whistles alerted a train to the danger of cattle on the track.

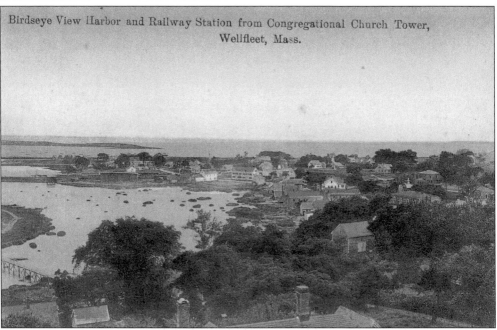

Birdseye View Harbor and Railway Station from Congregational Church Tower, Wellfleet, Mass.

WITH PROGRESS COMES LOSS. Wellfleet shipped mackerel and oysters to market by railroad, but the railroad dike, seen at the upper left, cut off the town's inner harbor. In 1938, with the automobile firmly established, passenger service died on the Cape. One reporter from the *Boston Post* wrote, "One effect . . . has been to disrupt a life-long habit with people in all the villages—that of visiting the post office for the evening mail. Mail time was the opportunity of the day for exchanging greetings with people and also swapping bits of gossip. . . . Now the post offices are deserted from late afternoon until the next morning; the stations are locked up, and no one is disturbed by locomotive whistling."

Nine

MARCONI'S
TRANSATLANTIC WIRELESS

*"I would like to meet that young man who had the monumental audacity to attempt and
to succeed in jumping an electrical wave across the Atlantic."*
—Thomas Edison

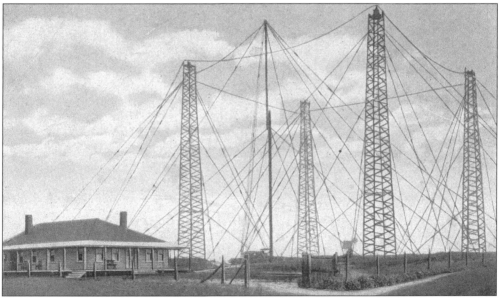

THE MARCONI WIRELESS STATION, BUILT IN SOUTH WELLFLEET IN 1902. The 20th
century's astounding advances in communication began in Wellfleet on the night of January
18, 1903, when Guglielmo Marconi sent the first two-way transatlantic wireless message from
America to England. That moment made it possible for the U.S. Navy to retire its homing
pigeons, for 712 lives on the *Titanic* to be saved, and for Pres. Theodore Roosevelt and King
Edward VII to strengthen the bonds between nations.

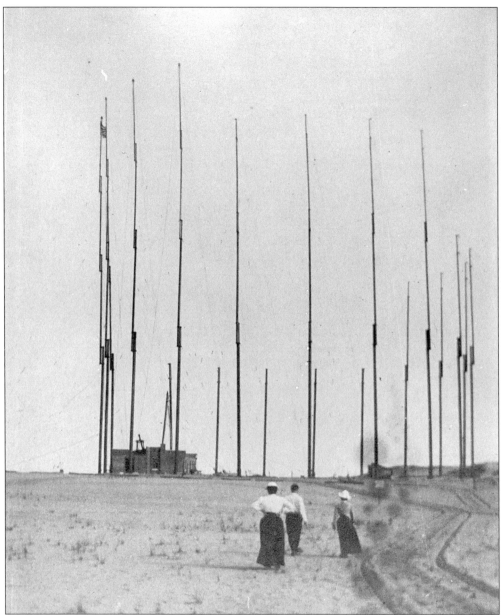

THE FIRST MARCONI STATION IN SOUTH WELLFLEET, BUILT IN 1901. Born in Bologna in 1874, Marconi began sending wireless messages at the age of 20. The first message traveled 30 feet and then 100 feet and then one mile to the inventor's brother Alfonso Marconi, whose answer was a celebratory gunshot in the air. Marconi went to England where he impressed Queen Victoria with his wireless reports of the Kingstown Yacht Regatta. To accomplish what he called "the big thing," Marconi built wireless stations in Poldhu, England, in Nova Scotia, and on Cape Cod. In February 1901, Wellfleet salvager Ed Cook, escorted the inventor in search of a good site, first to Barnstable and then to the Highland Light in Truro and finally to South Wellfleet. Cook sold Marconi 8 acres of his own land for $250. Engineers built a circular antenna out of 20 ships' masts. Cape Codders flocked to the site. Some predicted that the next storm would tumble it all down. On November 25, 1901, a northeaster did just that. (N.S.)

MARTIN REIMERS AND LOU PAINE. These two local riggers helped build Marconi's towers in Wellfleet.

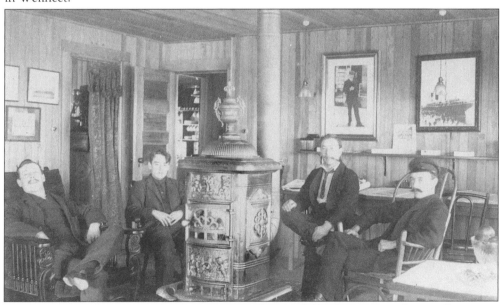

MARCONI'S CREW, H.W. HALLETT, DOUGLAS SMITH, P.W. PAGET, AND JULIAN BARRE AT THE SOUTH WELLFLEET STATION BUNGALOW. By December 11, 1902, the South Wellfleet Station was reconstructed, using four massive wooden towers. With it were a massive generator that sent off huge blue sparks, which to the locals' dismay could be heard five miles downwind, and a comfortable bungalow. The station was adorned with handsome stoves and a piano on which, it is said, Marconi himself entertained.

DINING ARRANGEMENTS. Steward Julian Barre oversaw the dining room at the Marconi bungalow. Unused to the rural, sand-in-your-teeth nature of the Cape, Marconi preferred a table graced by linen and china, and the best food, bought locally or shipped in from Boston.

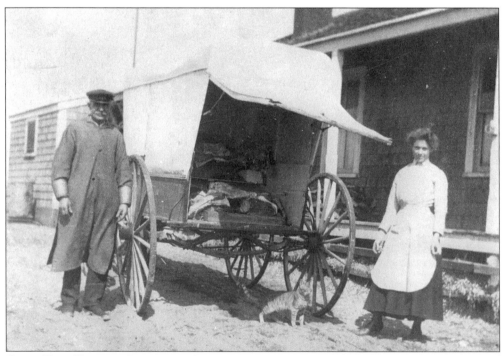

COOK EVA HIGGINS RECEIVING SUPPLIES FROM THE LOCAL BUTCHER. Eva Higgins of Wellfleet prepared meals and did laundry and cleaning at the Marconi Station. Posing by the butcher's cart is the cat Castagna, survivor of the Italian ship of the same name that wrecked nearby in 1905. Survivors of the shipwreck were brought here to recuperate, and the wise ship's cat stayed at the bungalow, where the food was good and the stoves were warm. (N.S.)

LORIMAR HIGGINS, SON OF THE MARCONI STATION COOK, LEANING AGAINST ONE OF THE GIANT TURNBUCKLES ON THE GUY WIRES THAT HOLD UP THE ANTENNA TOWERS. The Marconi Station on the cliffs overlooking the sea was an irresistible playground for local boys, regardless of danger. According to one story, "One bolt of lightning, flashing down the telegraph line, knocked the operator out of his shoes. He was only slightly injured, but the coal bucket was welded firmly to the stove." (N.S.)

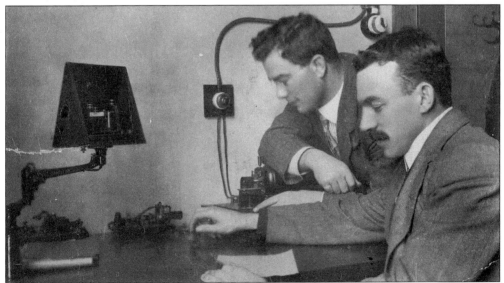

WIRELESS OPERATORS JACK SIMPSON AND P.W. PAGET. On the night of January 18, 1903, Marconi sent this message from the president of the United States to His Majesty, Edward VII: "In taking advantage of the wonderful triumph of scientific research and ingenuity which has been achieved in perfecting the system of wireless telegraphy, I extend on behalf of the American people most cordial greetings and good wishes to you and all the people of the British Empire. Theodore Roosevelt, Wellfleet, Mass." The King's reply, dated "Sandringham, Jan. 19, 1903," completed the historic moment.

THE RESPONSE. Charlie Paine and his horse Diamond brought the historic news to the depot to be telegraphed to the world: "Diamond and I had been waiting around off and on for about six days. I didn't know just when Mr. Marconi was going to need me, so I stuck to his orders and hung around close by his wireless office. When the great moment came—King Edward's reply came flashing right here to South Wellfleet all the way from Cornwall—Mr. Marconi dashed out of the station, very excited, carrying two messages in his hand. His orders to me were 'Drive like the wind and if you kill your horse I'll get you another one.'" Paine considered Marconi's words, and dismissed them. "Well I wasn't going to kill my horse, so as soon as I'd driven out of the sight of that excited man, I slowed Diamond down to a jog trot. But we made the depot in good time and the messages—one to the President and one to New York—went over the wires. Yes, I was plenty excited too, but still I wasn't going to kill my horse—not even for Marconi, the King of England, or the President of the United States."

GUGLIELMO MARCONI AND HIS WIFE, MARCHESA MARIA CRISTINA, ABOARD THEIR YACHT, *ELETTRA*, 1932–1933. In 1909, Marconi was awarded the Nobel Prize. His South Wellfleet Station linked the *New York Times* and *London Times* for quick international news, and it was his equipment that allowed the *Carpathia* to rescue 712 passengers from the *Titanic* in 1912. Marconi's daughter Princess Elettra recently identified people in this photograph for the first time: Marconi is at far right with Marchesa Maria Cristina. In the center is engineer Pession, and at far left is Marconi's associate David Sarnoff, who later became president of RCA. (N.S.)

THE HOLBROOK HOUSE, WHICH ONCE STOOD ON HOLBROOK AVENUE OPPOSITE CHEQUESSETT NECK ROAD. Marconi had set up his first headquarters here in 1901. In 1903, reporters from around the world stayed at the Holbrook House, and Wellfleet seemed, briefly, to be the center of the world. Marconi ushered in modern communications; however, when Italy's King Victor Emmanuel telegraphed congratulations, his message, routed to the South Wellfleet General Store, was taken to Marconi by horse and buggy.

PRINCESS ELETTRA MARCONI IN WELLFLEET TO CELEBRATE THE 125TH ANNIVERSARY OF HER FATHER'S BIRTH, 1999. Though the First World War and the erosion of the outer bank brought the South Wellfleet Station to an end by 1920, National Park Service exhibits and programs draw thousands to the site where Marconi changed the world. During her visit there and to the Wellfleet Historical Society exhibit, Princess Elettra Marconi spoke of her father's "deep concern for the comfort and safety of everyone . . . his great humanity, and his love for people."

Ten

WELLFLEET BECOMES A SUMMER RESORT

"Wellfleet is unsurpassed as a vacation land. For those who enjoy the beach with its pure, clean sand and warm bathing in clear water, or a cold plunge in the rugged surf . . . You will find our hotels and inns offer you quiet and restful comfort under perfect conditions . . ."
—Wellfleet Board of Trade, 1920s

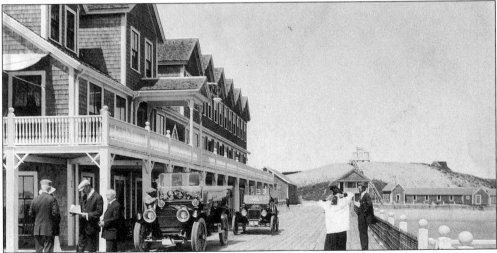

THE CHEQUESSETT INN. The inn epitomized the golden age of Wellfleet's resort era from the 1890s to the 1930s. As the country turned from fishing and farming to industry, families could afford escapes to the sea. After the coming of the railroad in 1870, Wellfleet began to shift from solely a fishing village to a resort and artists' community. The wealth of Wellfleet men, such as Lorenzo Dow Baker, helped transform the village at the start of the 20th century to one where pleasure yachts and elegant inns shared the same shore as the houses of fishermen and their weathered shellfish boats.

A Portrait of Wellfleet's Last Oyster House, Crumbling into the Sand at Shirt Tail Point. Today, the marina with its sleek sailing boats and the town wharf with its chugging fishing boats coexist on this spot. (N.S.)

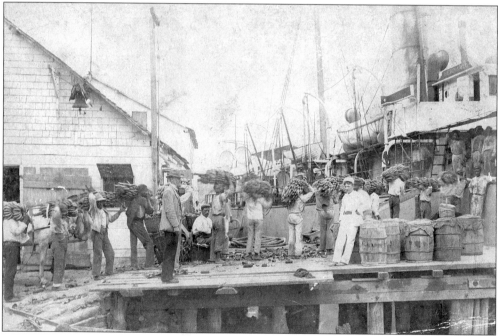

Bananas Being Loaded in Jamaica for Lorenzo Dow Baker to Ship to Boston. In 1870, Captain Baker needed to fill the empty hold of the schooner *Telegraph* while returning from Venezuela. In Jamaica, he picked up cargoes of pineapples, coconuts, and bananas. The latter proved so lucrative that Baker built a fleet, bought plantations, and introduced the northeast to bananas and Wellfleet to tourism.

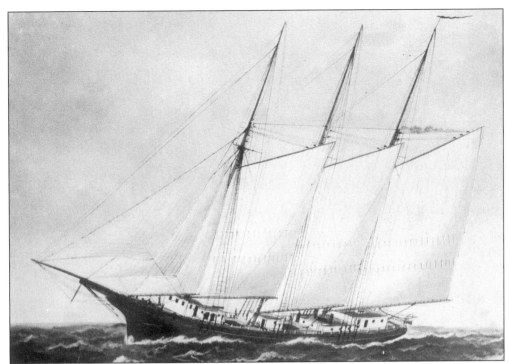

THE 500-TON BANANA SCHOONER *JESSE H. FREEMAN*. In 1880, Capt. Lorenzo Dow Baker joined with Wellfleet's Capt. Jesse H. Freeman to form the L.D. Baker & Company. A devoted Methodist, Baker hired an organist for his first ship, the *Vineyard*, for services and the hymns sung before each meal. In 1883, the schooner *Freeman* was built, combining both steam and sail.

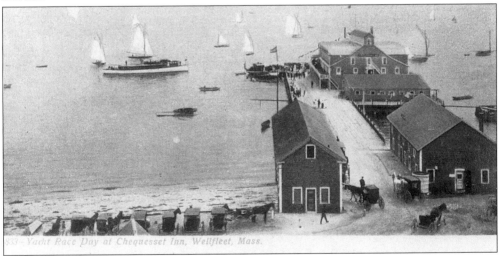

MERCANTILE WHARF AND THE CHEQUESSETT INN, AFTER 1902. The 1880s were pivotal. Lorenzo Dow Baker's brother-in-law Elisha Hopkins joined the company, then named the Boston Fruit Co., and Baker moved his headquarters and family to the island of Jamaica. Many in Wellfleet bought stock in the company and prospered with the Bakers. In Jamaica, Baker built a hospital and developed several schools. In Wellfleet, he invested in property, rebuilt the Methodist church and in 1885, bought the old Mercantile Wharf at today's Mayo's Beach.

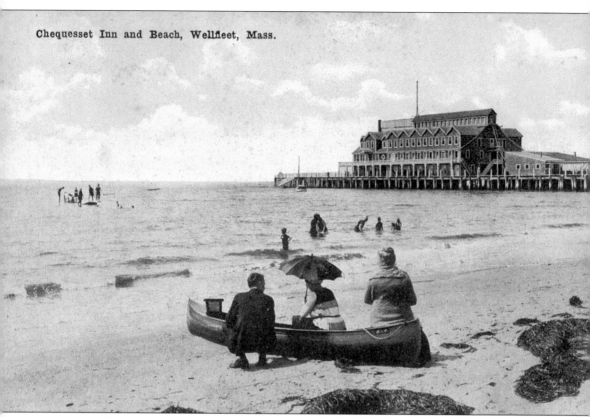

CAPTAIN BAKER'S NEW INN. Mercantile Wharf was transformed into the elegant, 62-room Chequessett Inn and opened by 1902. The brochure stated that the "Chequessett Inn is built upon a site unique among the hotels of New England, on the end of a spacious pier directly over the water . . . Our guests are sensible of the exhilarating conditions of a sea voyage with absolute exemption from its dangers. Beautiful Wellfleet Bay with its stretch of sand beach, creeks winding through green meadows, the picturesque village, Billingsgate Light and the Marconi towers, afford the sense of sight never ending delights."

LORENZO DOW BAKER'S HOTEL, THE TITCHFIELD, AT PORT ANTONIO, JAMAICA. Baker neatly operated his hotel in Jamaica and the Chequessett Inn by using the same Jamaican staff in both places, since the Titchfield was open only in winter and the Chequessett only in summer. (Photograph courtesy of Joan Hopkins Coughlin.)

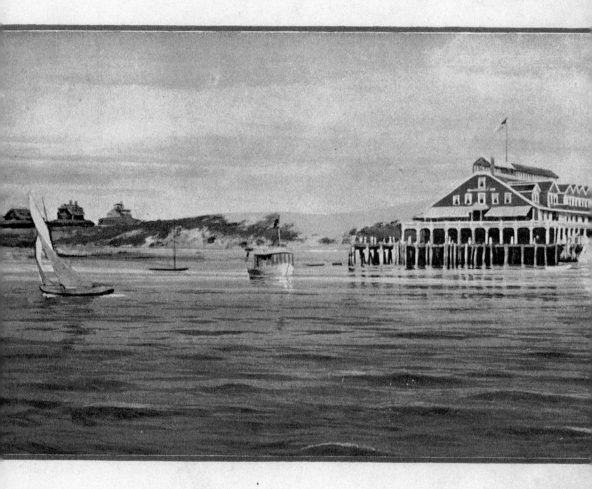

Located on the outer end of a broad and substantial
pier four hundred feet from the beach.

THE CENTER SPREAD OF THE CHEQUESSETT INN BROCHURE. Glossy advertising booklets showed the new face of a town transformed. The newly formed Board of Trade declared

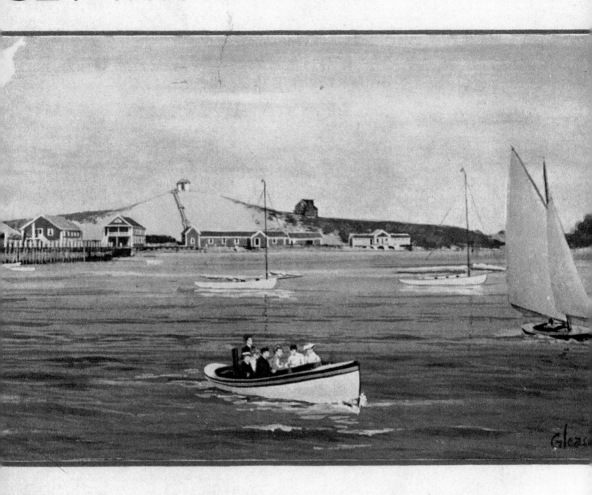

An original feature possessed by no other hotel
in America.

"Wellfleet welcomes you."

THE LIVING ROOM OF THE CHEQUESSETT INN. The inn's brochure proclaimed that "The house offers to patrons all the comforts and conveniences that could be wished. Airy and attractive living and dining rooms, open fire-places, a broad piazza entirely around the house suggest sociability, or invite rest and ease in shady nooks from which the beauties of nature may be quietly enjoyed."

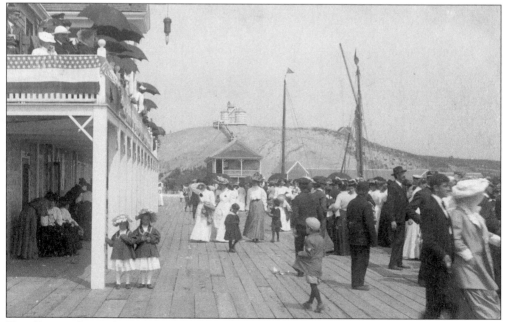

TWO LITTLE GIRLS POSING ON THE BROAD PIAZZA OF THE INN. The gravity-fed water system, seen on the hill and the inn's electric generators offered modern comfort for guests who came from as far away as the Midwest.

114

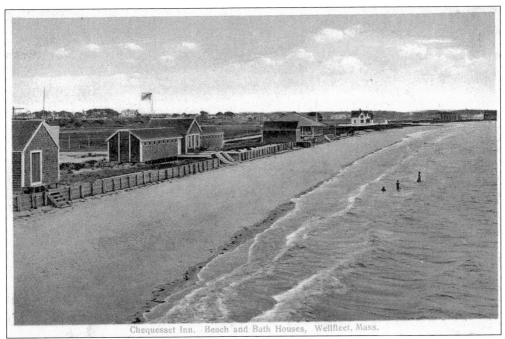

Chequesset Inn, Beach and Bath Houses, Wellfleet, Mass.

THE CHANGING APPEARANCE OF THE BEACH. Bathhouses lined the beach beside the Chequessett Inn. Note the old lighthouse keeper's house at the far right.

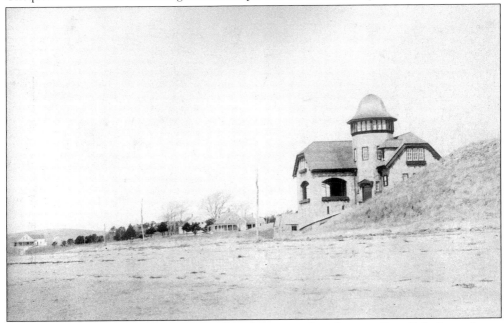

THE ELEPHANT HOUSE. To the west of the Chequessett Inn, Lorenzo Dow Baker's son Loren Baker built a beach house, sometimes known today as the "Elephant House." While importing bananas led to wealth for the Baker family, it was not without danger: "Mr. Ephraim Ryder, in unpacking a box of bananas, found among the fruit a Tarantula, a huge spider, which is a cannibal, or man-eater when his spider-ship has an opportunity to come into contact with human flesh . . . he was executed without trial." —the *Provincetown Advocate*, June 8, 1870.

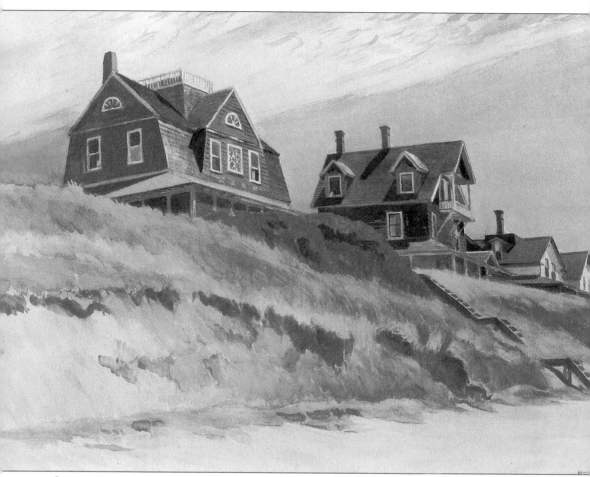

COTTAGES AT WELLFLEET, BY ARTIST EDWARD HOPPER. At Mayo's Beach, near the Chequessett Inn, Lorenzo Dow Baker built the Bluff Cottages for overflow guests of the inn. In 1933, Edward Hopper immortalized the cottages in a watercolor titled *Cottages at Wellfleet*.

SUCCESS BEYOND THE DREAMS OF A BOUND BROOK ISLAND BOY. By 1890, Lorenzo Dow Baker had built Belvernon, his substantial home on 5 acres off Baker Avenue. It was known for its bowling alley, tennis and croquet courts, and the bunch of bananas that was always hung on the porch for guests. Baker's Boston Fruit Company eventually merged with the United Fruit Company, which is now Chiquita Brands International.

BOYS. Lorenzo Dow Baker II, left, known as "Dow," and his second cousin John Hopkins pose for this photograph taken at Belvernon, *c.* 1905. (Courtesy of Joan Hopkins Coughlin.)

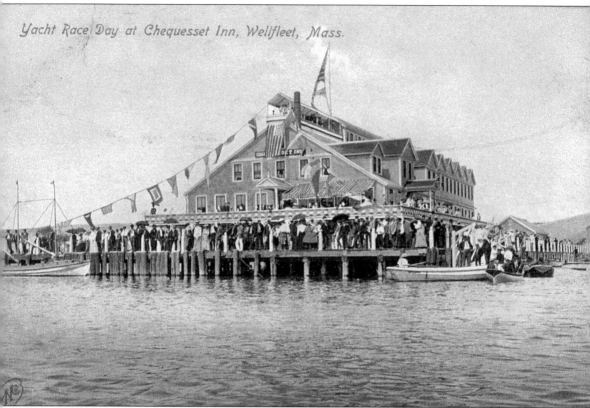

Yacht Race Day at Chequesset Inn, Wellfleet, Mass.

A REGATTA DAY CELEBRATION AT THE CHEQUESSETT INN. "Saturday the second day of the race was a fine one with a strong southerly wind. The boats went over the course and careening around the buoys like seagulls on the wing. There were four boats . . . *Harolde* of Winthrop, *Arawak* of Wellfleet, *Electra* of Provincetown, and the *Ishtar* of Barnstable . . . As all four boats in passing the buoy at starting were closely bunched together, the *Electra* broke her peak halyards, causing her to withdraw . . . The *Harolde* and the *Arawak* had a fine race, the former gaining by a slight margin," reported the *Barnstable Patriot* on May 11, 1896.

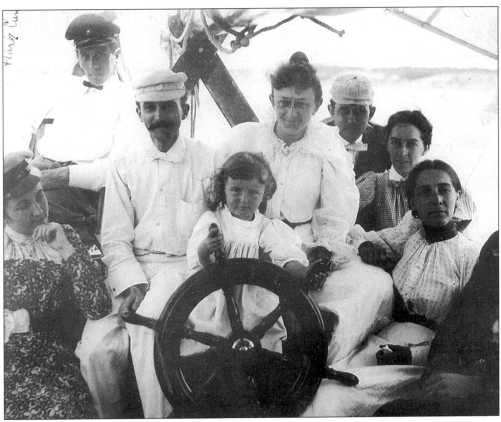

YOUNG CAROL MAYO NICKERSON AT THE WHEEL OF THE ARAWAK IN 1896. Carol Mayo Nickerson poses in front of her parents, Henry Crosby Nickerson and Dora Mayo Nickerson, and their friends. (Photograph used with permission of Carol Mayo Nickerson's granddaughter Susan Ryder Hamar).

Dinner.

CHEQUESSET INN, WELLFLEET, MASS.

	Steamed Clams	Quahaug Chowder
	Olives	Mixed Pickles
Boiled Chicken Halibut	Cream Sauce	
	Plain Boiled Potatoes	
Lettuce	Sliced Tomatoes	Cucumters
Escalloped Oysters		
	Prime Ribs of Beef au Jus	
Corned Brisket	Ox Tongue	Cold Ham
	Egg Salad Mayonnaise	
Mashed Potatoes		Green Corn
	Stewed Tomatoes	

DESSERT

Green Apple Pie

Fruit Cake	Vanilla Ice Cream	Walnut Cake
Boston Crackers		American Cheese
Apples		Iced Watermelon
Iced Tea		Coffee

BANQUET TENDERED VISITING YACHTSMEN
AUGUST 28. 1905.
BY WELLFLEET YACHT CLUB

THE CHEQUESSETT INN MENU FOR A BANQUET HELD FOR VISITING YACHTSMEN BY THE WELLFLEET YACHT CLUB. The banquet was held on August 28, 1905.

HOTEL CHEQUESSET

WELLFLEET. MASS. *on* Cape Cod

DONALD A. RAND
MANAGING DIRECTOR

Regular Dinners	$1.50

A LA CARTE

Shore Dinner	3.00
Lobster Dinner	2.50
Steak or Chicken Dinner	2.00
Broiled Lobster - Fr. Fr. Potatoes - Coffee	2.00
Lobster Salad - Rolls	1.50
Toasted Lobster Salad Sandwich	1.25
Chicken Salad - Rolls	1.25
Toasted Sliced Chicken Sandwich	1.00
Toasted Chicken Salad Sandwich	.75
Desserts	.25
Fruits in Season	.25

BEVERAGES

Pot of Tea or Coffee	.15
Iced Tea or Coffee	.20
Canada Dry Ginger Ale	.35
White Rock Water	.35

DINNER AT THE INN. The Chequessett Inn, later known as Hotel Chequessett, had an elegant dinner menu that listed a broiled lobster dinner with French fried potatoes and coffee for $2.

MOSQUITO TURMOIL. The tranquility of the Chequessett Inn was disrupted early on by the dreaded saltwater mosquito. In 1905, the Reverend G.J. Newton declared that "upwards of $20,000 was lost this season because people who came to town went elsewhere when they discovered how annoying these insects were." An expert from the American Mosquito Extermination Society suggested building a dike across the mouth of Herring River to drain the marshes above.

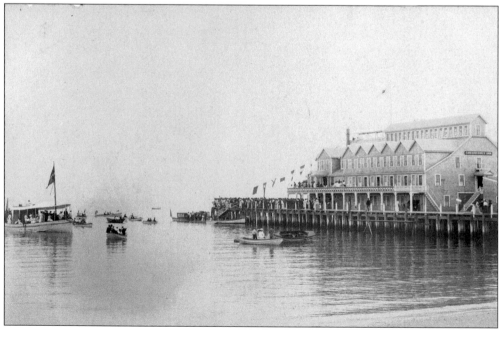

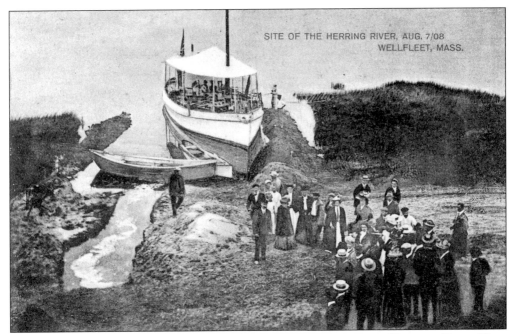

SITE OF THE HERRING RIVER, AUG. 7/08
WELLFLEET, MASS.

Townspeople Gathering to Celebrate the Completion of the Herring River Dike at Chequessett Neck, 1908. After the *Boston Herald* announced in 1907 that "Wellfleet, one of the prettiest towns on Cape Cod, is 'stung'" and that vacationers were going elsewhere, the dike was built. With it, the mosquito curse was controlled and vacationers returned to Wellfleet.

Ethel Hopkins, Grandpa Dick (Richard Baker Hopkins), Eva Johnson, Ethel Baker, John L. Hopkins, and Friends at the Beach. Johnny the horse is seen at the right. (Photograph courtesy of Joan Hopkins Coughlin.)

THE HOLIDAY HOUSE, WELLFLEET, CAPE COD, MASS.

THE FLOURISHING TOURISM INDUSTRY. The Holiday House, now the Inn at Duck Creek, flourished along with the Indian Neck Hotel, the Holbrook House, and the Wellfleet Hotel. By 1915, Joseph and Lalie Price of Philadelphia bought the house that Captain Holbrook had built in 1812. The Prices used the house as a summer residence until the start of the Great Depression, when they moved to Wellfleet. In the 1930s, they converted it into the grand Holiday House hotel, using some of the lumber salvaged from the Chequessett Inn after it sank into the harbor. The Prices also scavenged tall columns from the ruins of the old Libby Mansion. They placed them, however, on the back of the house, mistakenly believing that a new highway would pass on that side of the hotel. This graceful but hidden façade of columns is still visible today.

A CAREFREE AFTERNOON. Ethel Hopkins, the Covell cousins, and friends pose near the Bluff Cottages at Mayo's Beach. (Photograph courtesy of Joan Hopkins Coughlin.)

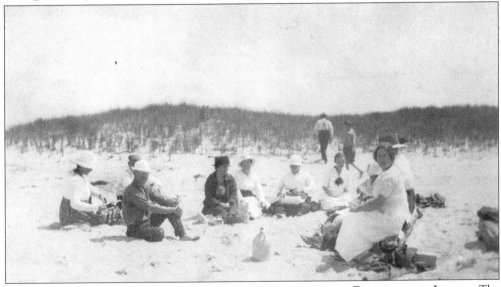

ETHEL HOPKINS AND HER FAMILY AND FRIENDS, PICNICKING ON BILLINGSGATE ISLAND. The island continued to be a favorite picnic spot for Wellfleet townspeople and vacationers, until it disappeared in the 1930s. (Photograph courtesy of Joan Hopkins Coughlin.)

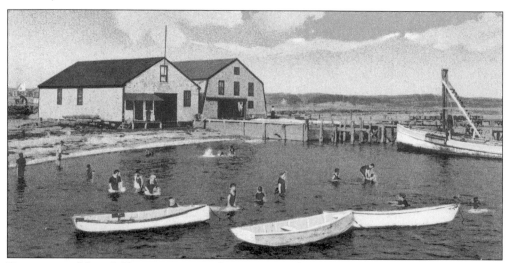

BATHERS AT MAYO'S BEACH, C. 1910. Swimming in the sea was something done by accident until roughly the middle of the 18th century. New Englanders hardly swam until Bostonians discovered the sport in the 1830s. Men and women were segregated on beaches, and their attire was strictly regulated. For 100 years, laws like Wellfleet's "chin-to-knees" regulation kept bodies under yards of wool and cotton. After quite a bit of heated discussion, a Wellfleet town meeting overturned the chin-to-knees law in 1935.

THE WELLFLEET BASEBALL TEAM POSING ON THE BEACH DURING OLD HOME WEEK, c. 1900. Team members seen here, from left to right, are as follows: (front row) Henry DeLory, the batboy, Claud Berrio, Charles Williams, Frank Rose, and Mott Small; (back row) James Curran, ? Bailey, Willie Lane, William H. Gill (umpire), William Rose, and William DeLory.

TOURIST CABINS. The Milton Hill Cottages were among the first tourist cabins in Wellfleet. Known also as the Lemon Pie Cottages (they were painted yellow with roofs so peaked that they looked like slices of pie), they were brought by Lorenzo Dow Baker from the Yarmouth Campground to this spot overlooking the Town Wharf. Dick Rich's boat *Helen* is in the foreground.

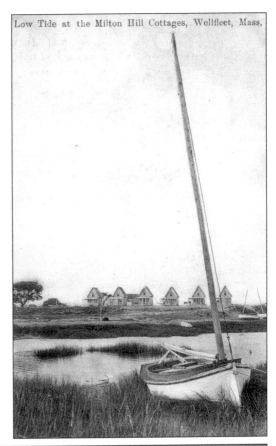

Low Tide at the Milton Hill Cottages, Wellfleet, Mass.

THE FURY OF THE WIND. Wellfleet Harbor was not always a "Snug Harbor," as the Milton Hill cottage on the left was called. A hurricane in the 1930s toppled its neighbor onto it.

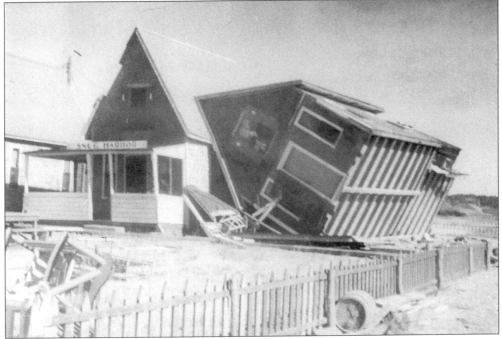

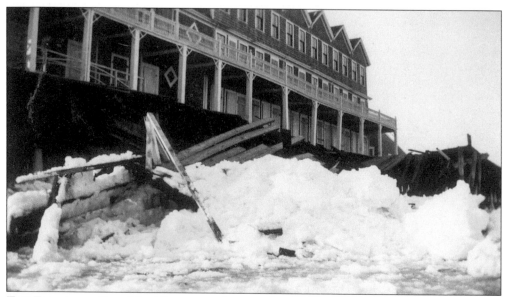

THE END OF AN ERA. The Chequessett Inn was destroyed in 1934. "Swiftly moving ice floes swept across Cape Cod Bay by a high southwest gale today threatened destruction to the Chequessett Inn, a large summer hotel built over the water, after carrying away 300 feet of wharf, and tearing out pilings," reported the *Boston Traveler* on March 3, 1934.

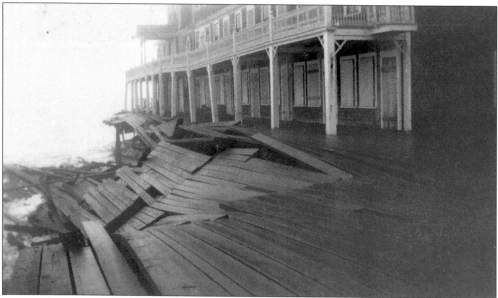

DESTRUCTION BY ICE. The *Boston Traveler* reported on March 3, 1934, that "The four-story structure, overlooking Wellfleet Bay, buckled in the center as ice cakes pounded heavily at the base . . . The ice in the bay broke under the thawing southerly winds, and floes a mile or more across were sent scaling toward the lower Cape, some gnawing at pier pilings, boat and fish shanty foundations and other property along shore." The remains of the Chequessett Inn were torn down the following July, leaving only the stumps of pilings, visible at low tide.

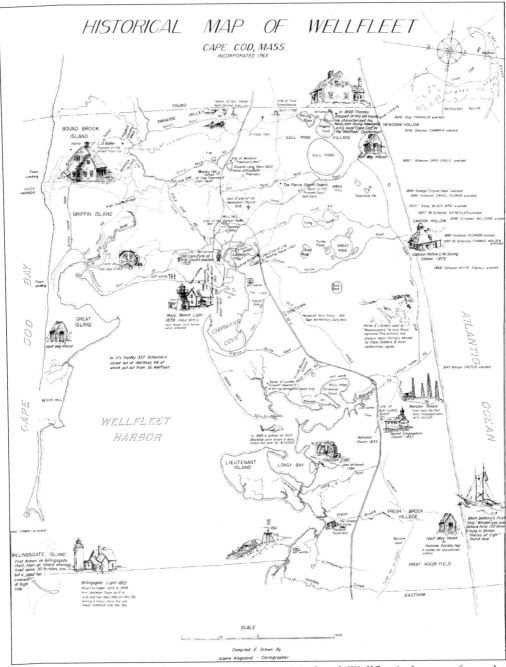

RECOLLECTING WELLFLEET'S VARIED HISTORY. Much of Wellfleet's history, from the Punanokanit Indians through its sailing days, Thoreau's visits, and the town's first flush as a summer resort, can be traced in this map, created by Ailene Kingsland in 1963.

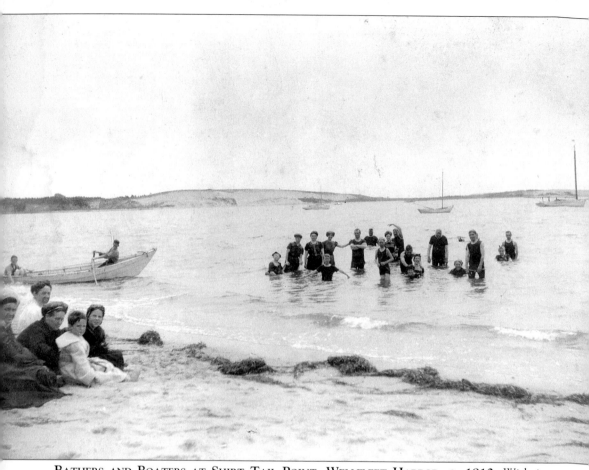

BATHERS AND BOATERS AT SHIRT TAIL POINT, WELLFLEET HARBOR, C. 1912. With its countless ships and unceasing tides, Wellfleet seems always a place of departure and return. When Henry Thoreau left the home of the Wellfleet oysterman in 1849, he wrote, "Finally, filling our pockets with doughnuts . . . and paying for our entertainment, we took our departure . . . he directed us 'athwart the fields,' and we took to the beach again . . ." (N.S.)